COLD WAR/
COLD WORLD

COLD WAR/
COLD WORLD

Edited by

Amanda Beech, Robin Mackay, and James Wiltgen

URBANOMIC

Published in 2017 by
URBANOMIC MEDIA LTD,
THE OLD LEMONADE FACTORY,
WINDSOR QUARRY,
FALMOUTH TR11 3EX,
UNITED KINGDOM

CaLARTS

Publication of this volume was supported by CalArts.

BRITISH LIBRARY CATALOGUING-IN-PUBLICATION DATA

A full catalogue record of this book is available
from the British Library

ISBN 978-0-9954550-8-5

Type by Norm, Zurich
Printed and bound in the UK by
TJ International, Padstow

www.urbanomic.com

Contents

Cold War Cold World is a research group based in the Center for Discursive Inquiry in the School of Critical Studies, California Institute of the Arts, USA. Bringing together a core group of international researchers and discussants, the project has manifest in a series of workshops, seminars, and events that investigate the condition of the image, representation, and knowledge in the site of alienation, contingency, and complexity. Working at the interface of artistic production and philosophical inquiry, **Cold War Cold World** continues to produce forms of culture and thought that can meet these demands. This collection of essays documents the first series of discussions from the group and its affiliates extending from the symposium *Neo-liberalism, Neo-Con, Neo-Noir*, held at California Institute of the Arts, November, 2016, together with additional interventions and responses selected and commissioned by the editors.

James Wiltgen and Robin Mackay

Introduction: Cold War/Cold World— A Project of Reason?

> The essential point is that in characterizing an episode of *Knowing* [...] we are placing it in the logical space of reasons, of justifying and being able to justify what one says.[1]

The Cold War—as historical event, as scientific-military configuration, as interlaced sociological, political, and economic phenomenon—careens between monotonic and non-monotonic logics, as the paradigmatic instantiation of a type of 'procadence', a crystalline formation that signals, simultaneously, both *Saved!* and *Doomed!*[2] It also ushers in a type of Prometheanism of both the right and the left, in which the pathologies unleashed by the vastness of potential destruction vie with the complexity and compelling prospects of potential production: as exemplar, the White House press release of 6 August 1945, following Truman's decision to drop the first bomb on Hiroshima, declares:

> It is an atomic bomb. It is a harnessing of the basic power of the universe. The force from which the sun draws its power has been loosed....

Beginning with the First and Second World Wars (deemed by some a 'modern' 30-Years' War), the Cold War continued and intensified a series of cascading combined and uneven geotraumatic shocks that engulfed the entire planet, with enduring effects of concussion, disequilibrium, and jarring inquietude. A drive toward annihilation seemed an unrelenting element of this Cold War, a question for detectives of all stripes, as it generated an absurd redundancy of thermonuclear arsenals on the part of both the USSR and the USA—in

1. W. Sellars, *Empiricism and the Philosophy of the Mind* (Cambridge, MA: Harvard University Press, 1997), 76. This will in many ways be a stark contrast to the possible sophistry of Octave in *The Rules of the Game*, with his comment: 'The awful thing about life is this: everyone has their reasons'.
2. G. Deleuze, *Cinema 2: The Time Image*, tr. H. Tomlinson and B. Habberjam (London and New York: Continuum), 89–92.

effect, why all the guns? But more profoundly, why the quickening to abject destruction? One might argue that the human species has always been poised on the cusp of extinction, but the Cold War supplied a powerful psychological and technological matrix for this precarity, and instigated a temporal urgency that reanimated certain theological thematics.

Given the existential uncertainty unleashed for those who lived through the Cold War, the repercussions of which are in many ways amplified, relayed, and replayed in a new form for those who must now survive what has been called the 'Cold World'[3]—that of technological subjectivation, political malaise, cultural dysphoria, and ecological crisis—this terrain comprises an experiential and experimental horizon that prompts many to pose, and to stage in myriad forms, a fundamental question: 'What will we of make of ourselves?'[4]

If the term 'Cold World' describes a world of infinite complexity, algorithmic capital, and the technological sublime, the dread experienced during the Cold War, when clear oppositions were laid out between nation states, is in many ways echoed in the hall of mirrors of Cold World globalization, where our collective consciousness is overtaken by a flood of difference, uncertainty, and the dread incomputability of this alien yet constructed world. What is our place here, and how do we even compute the 'we' that we describe ourselves to be?

Cold War/Cold World has been imagined in large measure through a series of further questions that evaluate and respond to this fundamental shock to the system. It examines the task of rendering knowable, representable, or figurable the looming threats of both Cold War and Cold World—the common denominators being a distressed attempt to inquire into the dynamics of a real that seems in excess over understanding and the means of politics traditionally conceived, and a concomitant temptation to abandon any intelligent collective

3. Although in the context of this project we do not restrict the term to any particular formulation, the primary reference here is of course Dominic Fox's *Cold World: The Aesthetics of Dejection and the Politics of Militant Dysphoria* (London: Zero Books, 2009), addressed directly in Christine Wertheim's contribution to the volume.

4. R. Mackay, 'Immaterials, Exhibition, Acceleration', in Y. Hui and A. Broeckmann (eds), *30 Years Les Immateriaux: Art, Science, Theory* (Lüneberg: Meson Press, 2015), 215–44: 240; see also A. Mbembe on how humans as a species can 'begin-from-ourselves', A. Mbembe, *Critique of Black Reason*, tr. L. Dubois (Durham, NC: Duke University Press, 2017), 7; for provocative takes on nuclear weapons, among the vast literature, see the works of Kenzaburō Ōe, Susan Sontag, and Arundhati Roy.

engagement in favour of a pragmatics that limits itself to wrestling with local contingencies, or an aesthetics mesmerised by a global sublime.

These inquiries reveal and operate within what can be termed a question-problem complex, an integral approach that might be deemed—in an appropriation of cultural tropes appropriate to the *noir* of the Cold War scene—a type of quasi-ontological detective mode: What is the crime scene of the Cold World? How is it to be decrypted? Where are its discontinuities, what is the nature of its violence? Far from being a simple whodunnit, this case involves a problematization of the detective figure itself qua set of cognitive methods which in turn imply a model of the world and an image of thought—the suspicion being that *the time is coming when it will hardly be possible to write a detective story as it has been for so long...*.

Éric Alliez and Maurizio Lazzarato's analysis of the Cold War lifts the curtain on the original 'scene of the crime', delivering a forensic analysis of the forces at work beneath this supposedly familiar historical episode. They demonstrate clearly how, in deploying the political, economic, and technological spoils of the arms race into the social and domestic sphere via a militarization of peace and a cyberneticization of the social, the Cold War was instrumental in engineering a Cold World to come, and that both are best seen as phases in an ongoing mutation of the war machine constitutive of capitalism itself (the thesis of *Wars and Capital*, from which the text is excerpted).[5]

With Truman's tenure marked by domestic labour strife as the demobilization of WWII caused profound dislocations, the US government instituted new axiomatic formations with business to mutate and control workers and the lower classes, and the entire country was initiated into a new type of 'people's capitalism' based on a 'cold transdisciplinarity' generated by a 'reprogramming of social life in its entirety' via 'psychosocial engineering'. In many ways this involved a type of Washington Syndrome: Americans had been so traumatized by WWII (although in a markedly different way than much of the rest of the world), and then the strife of the postwar period, followed by the Korean War, that they appeared ready to trade a massive nuclear build-up for stability—Eisenhower's New Look, undergirded by the threat of massive thermonuclear retaliation—and a new wave of consumption via an insidious form of endocolonization, in the

5. *Guerres et Capital* (Paris: Éditions Amsterdam, 2017); translation forthcoming (Semiotext(e), 2017).

form of the primacy of capitalist-generated individual 'desire' (initially codified by Truman's NSC 68 in the American/capitalist concept of the individual-as-consumer being 'more *vital* than the ideology that fuelled Soviet dynamism'). As Alliez and Lazzarato point out, 'a war of missiles' is here 'doubled by a "gendered" war of commodities'. The existential global threat of annihilation and an internal machinic slaving based upon a proliferating consumer 'dream-world' would form the architecture of the globalizing project: America would become the principle avatar of a continually mutating capitalism based upon the potential ontological absolute of annihilation and the febrile seduction of a consumer cornucopia.

If, as Alliez and Lazzarato suggest, the Cold War 'mark[s] our entry into the cyborg age of cybernetic communication and control' and 'is itself a kind of cyborg' that couples the psychosocial dynamics of nuclear threat to the economic benefits of the indebted nuclear family, then it is no surprise that Cold War images of the social machine at once reflected a submission to cybernetic realism, and provided a backdrop for mythical fictions that tried to salvage the possibility of relative transcendence from the jaws of creeping nihilism. In particular, the Cold War gave birth to a specific narrative and cinematic world in which, above an irredeemably unjust world riven by paranoiac fear a heroic figure is raised, one who lives beyond the obsolete strictures of conventional law and social norms: a detective who grapples directly with the contingencies of the real, yet whose success in resolving local situations only serves to reinforce and reinscribe a global space of naturalised chaos, an all-against-all intractable to the intelligence and refractory to any thinking in common.

It is this world of noir that Amanda Beech sees reiterated not only in more recent Hollywood output, but also, intriguingly, in the conservatism of contemporary art in its confrontations with the neoliberal continuation of the cybernetic socius forged in the heat of the Cold War. For here, she argues, Art casts itself in an equally heroic role, in claiming to offer an access to the unknowable threat of the real that reason and politics cannot. Yet in privileging art as the sole site within which this real can be figured, and then only in a mode that repels cognitive traction and collective construction, this heroism inscribes itself within a new alienation as isolated and desocialised as that of the noir gumshoe.

In her call for a renewed thinking of *reason* against these figures of alienating alienation whose individualised transcendence resigns us to an atomised

Hobbesian noir, Beech reflects the recent emergence of a functionalist and pragmatically inflected attempt to develop an investigative 'critical ontology' coupled with an epistemic dynamics. For her as for others, this task involves the invention of a figure of 'reason' quite different from the reason whose strange love for relentless calculative machinations the Cold War is condemned for having accelerated uncontrolledly, to the point at which it revealed its inherent vice. This non-dogmatic, asymptotic, 'colder' type of reason—one where affect and emotion have been rethought and reconfigured, but by no means eliminated—is cognizant of the brutal past in which reason had been a principal means of expansion for the West's aggressive rationale. It announces itself as a thinking now under the aegis of collective, self-correcting, conceptually revisionary processes which incorporate the malfeasance of the past as well as the current moment, while remaining focused on a critical engagement with the future; a resolutely non-totalising approach based on the idea that questions posed by reason cannot be saturated by solutions, and one that implies a renewed and innovative relation with the imagination. Finally, it demands an understanding of how this 'new' reason, perhaps a neo-reason, functions within the continuum running from the *manifest* to the *scientific image*.

This distinction, which we owe to Wilfrid Sellars's understanding of the two basic ways in which humans view themselves and the world, is already implicated in the Cold War home invasion described by Alliez and Lazzarato, where the transfer of scientific-cybernetic management from the military to the social, rendering politics a matter of 'getting numbers out', is complemented by a regime of blandishments that serve to reinforce social subjection (*situation room/situation comedy, a Sheltered Honeymoon...*). The tensions of today's Cold World have seen the inherited image of the human individual as subject of social norms diverging yet more radically from the operational reality of a social machine processing mediated 'dividuals'. And yet the computational modelling of attention, decision, and identity continue to play a decisive role in the retrenchment of the ideology of the 'individual'. Although 'no one ever died of contradictions', the concomitant backdraft of Cold World social and personal pathologies poses a growing problem of containment, an increasingly acute load on the system charged with maintaining their separation yet ensuring their complementary function.

As an alternative to this *double-articulation* we might consider Sellars's insistence on the necessity of *intertwining* the 'manifest image' and the 'scientific image'. Moreover, Sellars advises that we understand the manifest image not as a fixed, 'pre-scientific, uncritical, naïve conception', but as an operative model that remains 'contemporary to the intellectual scene', and 'is not so much ontological as *normative* [...] it indexes the community of rational agents'.[6] The status of this enduring image evidently has crucial political implications for the thinking of the 'we,' of collective agencies—even more so given the suggestion that it may be transformed through its intertwining with the scientific image, the ensemble of current scientific models of the human. At the very least, Sellars's demand here necessitates that artistic, philosophical, and political agents take seriously both the scientific image in its most contemporary form along with the processes of inquiry that have yielded it and continue to refine it, *and* the 'space of reasons' that constitutes the manifest image, together with its machining via capitalist subjectivation.[7]

How then to understand the intertwining of the manifest and the scientific image, if both images possess constitutive autonomy, and if neither can be subsumed under the other? Here Sellars's protean notion of picturing, and its relation to the dynamics of the image, brings the concept of '*factual* truth', or 'truth as correct picture' under the aegis of the *image*[8]—returning us to the initial question posed to participants of the *Cold War/Cold World* project: What models (of reason, truth, justice, and the real) do we adopt when we seek to produce compelling *images* of the vertiginous cognitive disorientations of the Cold World, many of them born of the mobilisation of the scientific image? And what is their kinship with the models that underwrote the prevalent cultural forms of the Cold War, in confrontation with an unknown yet absolute threat? As Beech demonstrates, in both cases, the modes of detection proposed by investigators, and the questions they ask, tend to default to an *outside of intelligence* and an *individual transcendence*, staging a disintegration of the manifest image and thereby closing off the option of any collective renegotiation of it.

6. W. Sellars, 'Philosophy and the Scientific Image of Man', in *Empiricism and the Philosophy of Mind*, 1–40: 6–7, and R. Brassier, *Nihil Unbound: Enlightenment and Extinction* (Basingstoke: Palgrave, 2007), 5 (italics in the original).

7. Sellars, *In the Space of Reasons*, pp. 386-393.

8. J. F. Rosenberg, *Wilfrid Sellars: Fusing the Images* (Oxford: Oxford University Press, 2007), 57 (italics in the original), and chapter 5, 'Sellarsian Picturing'.

The question then becomes how generate new images of collective agency that are not transfixed into inaction by the sublime chaos of contingency, but work with and within its complexities. In what ways can images and narratives construct agents who might decipher both the mutable continuum and cascading contingencies that we determine in our descriptions of the Cold World? How can the Cold World, with all of its apparent instabilities, become a site for a reconfigured comprehension of patterns and rules? Can our understanding of this site of 'lawlessness' and alienation contribute to the enhancement of a collective rationality?

Such a task may involve the repurposing of a number of tropes that have been generally regarded as highly detrimental to any 'collective-based' emancipatory project: firstly, *nihilism*, rather than a 'pathological exacerbation of subjectivism', becomes 'a speculative opportunity', a mode of 'active nihilism' focused on the stratifications pervading immanence and the ways in which these structures can be mapped, altered, and augmented.[9] The idea of *alienation* similarly undergoes an elemental re-engineering via an enhanced attention to norms and rules, one that challenges the dominance of neoliberal orthodoxy while evading the dangerous contours of reactionary modernism through a resolute engagement of reason with the imagination in order to instantiate a 'collective activity [...][as] the deliberate construction of alienation that separates us from what *is*, toward the foreignness of what *could be*'.[10]

Robin Mackay's analysis of *Invasion USA* examines how the propagandist use of images of excessive threat may serve as an invitation to nihilism, ultimately exciting spectators not to mobilisation but to passivity. In the 1952 movie, hypnotized citizens are bombarded with 'hot' images of the effects of a full-scale invasion by the Soviet Union, complete with rampant use of the atomic bomb on both sides, in order to reinvigorate their collective consciences. Mackay's essay offers a comparison of this cinematic Cold War scenario with contemporary '*machinema*,' a type of image-apocalypse, whose cooling down by contemporary art via the gallery and the museum produces a comforting form of elective hypnosis. The threat of extinction has been transferred from the

9. Brassier, *Nihil Unbound*, xi.
10. P. Reed, 'Postscript: Constructing Assemblies for Alienation', in M. Miessen (ed.), *Crossbenching* (Berlin: Sternberg/Merve, 2016).

external to the internal via a 'cybernetics of control', but 'rather than unveiling the *real* of the image' as a component in the Cold World's machinic network, art tends to 'present us with a hypnotic collage that offers the *thrill of the real'*, replaying the Cold War scenario by offering an edifying spectacle that ultimately traps us in the closed circles traced out by Beech. He then offers a fundamental question, one of several firmly encoded in this book, namely 'How does art make images that image the yet-to-be-known'? Reiterating the warning of *Invasion USA*'s lugubrious prophet Mr. Ohman, Mackay's suggestion is that the need to '*concentrate*' on the trajectory of images in the technological dynamics of the contemporary moment must mean something other than being mesmerised by them, if we are to transform passive into active nihilism.

Christine Wertheim also looks to nihilism as a crucial place to assess the artistic, but also political, potentialities in the contemporary moment. In an important corrective to conceptions of the Cold World which rely too heavily on an exaltation of radical contingency or intrinsic randomness, she follows Dominic Fox in mining the resources of adolescent disquiet for strategies to exit the 'stuckness' that seems to pervade the social and political life of adults. For Fox in *Cold World*, the essential difference in some ways would be between Eliot's *Wasteland* and Beckett's *Endgame*, where in the latter 'the world is not losing its mind but its contents'.[11] For Wertheim, however, rather than contingency being the defining problem, the essential malaise is nihilism, the dangerous temptation of many adolescents in the face of the Cold World being to turn inward and to wage war upon themselves, or to focus on the symbolic economy, with mixed results. Wertheim looks to both Ulrike Meinhof and to 'delinquent girls', eschewing Fox's concentration on male artists (his perusal of Meinhof in the last chapter of his book, Wertheim argues, sees her actions as both mystery and failure). Doubtful that the void of the world and the societal can be overcome by 'a simple recognition of blind chance', she utilises Lacanian psychoanalysis, and specifically a group who work exclusively with highly disturbed adolescents, to argue that the struggle involves 'the very structure of the psyche itself': humans are alienated by their very existence, language is flawed, and *jouissance* under-mines any ability to fully symbolize reality. Nihilism, for Wertheim, is structural, and the ethical and political task she sets out suggests a trajectory far removed

11. Fox, *Cold World*, 5–6.

from that of Fox's protagonists of contingency (and that of Beech's noir hard cases). In this sense, alienation would be an inherent part of the Unconscious, of *jouissance,* of charting the terrain of the unsymbolizable. Any notion of overcoming it must therefore yield to the formulation of tactics for dealing with its ravages, but also for the actualization of new collectives, and differential local and geopolitical structurations.

Given the evident importance of generating new fictions and figures in order to weather the cold—to overcome the structural pain that is born by the mismatch between the demands of the manifest image and a Cold World that refuses to satisfy them—Brian Evenson's subtle analysis of the relation between fiction and personal experience grants a surprisingly positive role to an affect often seen as betokening mere escapism. Recalling Mackay's uneasy memoir of Cold War terror as a formative experience, Evenson's analysis understands *nostalgia* as a transference of pain, and reflects upon its possible metamorphosis through art.

Evenson begins with an almost *longue durée* approach here, assaying the trajectory of writing from the beginnings of modernity: the basic problematic that emerges involves the opposition between the mimetic and a type of shaping, or constructivism. Even the mirroring of reality by writers will be subject to the shifting sense of what the mirror does, as it becomes less a 'clear' reflection than an instrument subject to distortion and corruption, deforming the image according to the skill and style of the artist. In an intriguing manoeuvre he then morphs the concept of nostalgia into a possible site of non-fixity, of a dynamics of excess, and of a possible non-linear temporality where the lost object will be 'replaced' by the attempt to capture 'lost' intensities. Nostalgia will be transformed into/as pain, and materialised as art—and nostalgia in this transformed mode will be 'communal not individual'. Considering the bi-polar peoples of Beszel and Ul Qoma in China Miéville's *The City & The City,* subject to the most extreme form of reciprocal unknowing, Evenson highlights the overlap or crosshatching of their apparently binary domains: 'underneath' this formation exists a possible third city, a speculative and intense city as occasion for art, and as an occluded site of both the Cold War and the Cold World.

Bringing us back to the figure of the detective, Reza Negarestani's contribution offers us a portrait of the breakdown of the very method of detection itself,

and a portrait of a new agent who will challenge the most fundamental figures of 'reason'. Using the case of Matthäi, the detective in Friedrich Dürrenmatt's 1958 novel *The Pledge*, Reza Negarestani challenges both deductive and inductive modes of analysis, indicting traditional detective fiction, but also contemporary modes of hard realist fiction, those generated by the forensic and procedural techniques characteristic of neoliberal capitalism's appropriation of scientific method. Working through a Humean critique of induction, and further refining his approach first with Nelson Goodman, and then Hilary Putnam's reworking via Gödel's incompleteness theorem, Negarestani pushes the corrosive of epistemic scepticism to the point at which cognitive science becomes 'a pseudo-science', computational functionalism is bankrupt, and one can no longer 'trust' the blind god of evolution. Negarestani's solution will be as provocative as his diagnosis: armoury of reason at the ready, the detective must also regularly top up his hip flask with the 'superacid' of epistemological scepticism....

Negarestani's analysis of the inadequacy of Matthäi's method immediately brings to mind another unorthodox and strategic Cold War detective, Roberta Wohlstetter. Wohlstetter used a key conclusion from her earlier attempted dissertation on Hamlet—that the Danish Prince's perceived solipsism could be interpreted 'as a reflection of crisis in Western societies during periods of intense pessimism'—as a marker for a path-breaking work, a careful scrutiny of the attack on Pearl Harbor in December, 1941, and by extension its implications for thermonuclear warfare.[12] In doing so, she testified, like Dürrenmatt, to the Cold War's forcing of the compelling and potentially existential questions addressed by Negarestani: how to think a future different from the past, and how to address the overarching human incapacity to anticipate the unfamiliar.[13] Her conclusions, which converged with both those of her husband Albert Wohlstetter and those of the pre-eminent military think tank RAND in Santa Monica, CA, where both worked at the time, asserted the necessity for the dominance of 'imaginative possibilities, rather than reasonable probabilities'—in other words, build into the military system such incredible redundancies that the Soviet Union would be convinced the United States had the military might and strategic will to engage

12. R. Wohlstetter, *Pearl Harbor: Warning and Decision* (Stanford, CA: Stanford University Press, 1962). See R. Robin, *The Cold World They Made* (Cambridge, MA: Harvard University Press, 2016), 34–5.
13. Robin, *The Cold War They Made*, 59–60. (Existential questions are often the favoured terrain of the more unorthodox detective.)

in a thermonuclear war that 'fell short of global extinction'. From Wohlstetter's
investigations of the 'failures' of US military intelligence which led to the attack
on Pearl Harbor, she argued that another surprise attack could happen and
almost certainly would, that imaginative strategies must be put into place
to counter this, and that the only means by which the 'goals' of deterrence
could be accomplished would be an unprecedented defence profile capable of
withstanding any first strike by an adversary, and delivering a devastating and
decisively massive retaliatory blow to that enemy (conclusions her husband
would then use as a linchpin for his 'strategic balance of terror'). Here the Cold
War begets one type of Cold World, as the operational axis explicitly stated here
would involve embracing uncertainty via a post-Clausewitzian thermonuclear
defence so overwhelming that it becomes offense.[14] This thinking is one of the
more chilling ways in which thinkers come to grips with perhaps the central
issue creating a through line between the Cold War and the Cold World, one
which continues to create geotrauma of varying configurations and intensities
as, in Mackay's words, the 'absoluteness of the threat relativises everything',
and humankind and the planet continue to seek multiple vectors to traverse
this 'ontological alienation'.

As the escalation of the Cold War exploded the logical space of reasons,
then, it also discovered the force of fictioning (something like the deliberate
construction of 'unknown unknowns' *avant la lettre*; as Beech remarks, 'abstract
fictions are woven into the fabric of the space of reason'), overstepping the
'hard realism' of technoscience and naturalisation (the subsumption of everything
to hard facts, 'to get numbers out'). The resulting vision of futurity therefore
implies not only potential empirical destruction but also, and more profoundly,
epistemic disturbance. As suggested by the texts collected here, this double
impact can lead the investigator to recoil, if not into immobilised fear, then into
more or less explicit abdications of systematic understanding and narrowed
vistas of expectation. Optimistically and ambitiously, Negarestani instead relays
Dürrenmatt's urgent call to update the customary model of knowledge production

14. Ibid., 11, 20–21, 62–63. There has been great controversy about her work on multiple levels:
Suffice to say, both her analyses and those of her husband were to have a dramatic impact. This work
also has powerful connections with that of Herman Kahn, a colleague of the Wohlstetters at RAND
and one of the inspirations for Kubrick's *Dr. Strangelove*; his most important book was crucial to the
era: *On Thermonuclear War*.

as reflected in the classic persona of the detective. Epistemological scepticism becomes a resource for the possibility of rethinking both manifest and scientific images, and the aspect of Cold World 'realism' is transformed, its figure now a 'true detective' disenchanted of all certainties yet committed to ongoing epistemic inquiry.

Two responses from Joshua Johnson and Patricia Reed relay this call, and consolidate the question-problem complex tackled by the other contributions.

Taking up the philosophical challenge to scientism that Negarestani sees dramatised in Dürrenmatt's fiction, Johnson returns to Sellars's proposal for reconfiguring the connection between *ought* and *is*—between the space of norms that constitute the manifest image, and the space of naked contingent causality that is the locus of Cold War and Cold World fear. He highlights some recent developments in cognitive science (descended from the very 'cold interdisciplinarity' that Alliez and Lazzarato condemn—the irony perhaps symptomatic of a faultline at once philosophical and generational) which may provide exemplary tools for the 'stereoscopic' fusing of the two images, at once suggesting ways to understand the human decision-making process, and potentials for extending the possibility of artistic action into tactical aesthetic intervention, as an indispensable component of a collective political strategy.

In her concluding text, Patricia Reed provides a concise symptomatology of the reactive formations occasioned by the 'humiliations' of Cold World existence. In response, her outline of a collective action to counteract their passivity demands that we grasp the 'decentring' of the human as an opportunity, through a considered mobilisation of the hypothetical and the otherworldly in new collectively-constructed fictions: the 'affective "heat"' generated by estrangement must be channelled into a deliberate and optimistic programme of alienation. Here as in Johnson's text the decoupling of dizzying complexity from impotence, of the unrepresentable from the unknowable, of depersonalisation from dehumanisation, becomes the task of the imaginative resources of art in the broadest sense, fuelled by the 'abductive power of the hypothetical'.

As Johnson's examples suggest, this will involve an occupation of the technological sites from which dimensions of the Cold World can be rendered tractable to new modes of enhanced conceptual labour—in effect, modes of imaging able to deliver nonhuman indices of the real as resources for wresting

back agency in Wohlstetter's 'imaginative possibilities, rather than reasonable probabilities'. Where images, figures of knowledge, or 'maps' are liable to be understood as totalising and definitive, or as mere local charts with no capacity for broader orientation, Reed invites us instead to understand them as existing in a dynamic relationship with the complex territory they aim to map—imaging as an engine not a camera; modelling as a participant in worldbuilding.

The texts collected here range across the breadth and depth of a research project in progress, grappling with the question of the agency of the image as it operates both within and against knowledge and cognition. If the images and figures we use to portray the contemporary condition imply epistemological dramas in which we are implicated as actors and investigators, then understanding the epistemic models implied and (re)produced by their form and content goes hand in hand with the project of producing new figures of inquiry, cognition, and potential transformation. In the face of a Cold World subjectivation which, as Alliez and Lazzarato clarify, is largely the ramified product of the Cold War machine, such figures may, as Reed suggests, require us to forge new conceptions of the subject. As Negarestani insists, they will imply a new negotiation of our cognitive relation to future events; and, contrary to those figures of the noir tradition analysed by Beech, they should not cede the normative space of the social quite so readily. They may even be conditioned by nihilism or by nostalgia, but should not yield to the hypnotic glamour of the unbearably fragmented, the absolutely contingent, or the stupefyingly totalised.

Expressed in varying ways throughout the texts collected here is a call no longer to be transfixed by the alluring abstraction of such melodramatic clichés, but to commence unfixing, fictioning, and intertwining the multiple images of the human and its planetary, political, and existential situation in practices fuelled by the imaginative possibilities opened up by extended cognition and a remodelled reason. Although far from guaranteeing us *Saved!*, such a project may serve to counteract a passive resignation to our *Doomed!* predicament by intelligently grasping the complexity, extremity, and unpredictability all too often envisioned, in a projection of the darkness of human unknowing, as a numinous, overpowering cloud overshadowing intelligence and threatening collective survival.

Éric Alliez and Maurizio Lazzarato
The Cold War, at Home and Abroad[1]

The Cold War is often defined in terms of the 'arms race', as if the latter were specific to this period and to this phase of capitalist development. To which we might object that military Keynesianism is, in one form or another, a continued condition of the growth of capitalism. Or, to say it in another way: 'War' has a directly economic strategic function that the Cold War merely renders more obvious by expanding the role it plays in social control. [...]

The history of the Cold War is an *American history* written from start to finish by the superpower that emerged victorious out of two world wars. Supercharged by the full employment and technological innovation of the war economy, which had boosted productivity and mass consumption through the logistical militarization of society in its entirety (*military subsumption*), the US affirmed itself as *creditor* power of a new world order generated by the socialisation and capitalisation of total war. This took the form of an imperialism *so deterritorialized* that one can only call it 'anti-imperialist' in the sense that it accelerates the disaggregation of classical imperialism.[2] There is a deterritorialization of expansion, which is no longer territorial, *and a deterritorialization of war* which subtends neocolonial decolonisation and the geopolitics of economic aid: both of these come back to the investment of surplus capital under the global protection of the market of the Pax Americana. But the Cold War is not only the deterritorialization of the inter-state war directed against 'Soviet imperialism' and 'communist slavery'; it is, both *at home* and *abroad*, a new biopolitical regime: that of the *endocolonisation* of the population as a whole, submitted to the *American way of life*—which must decidedly be inscribed at the heart of the

1. Text translated by R. Mackay, excerpted from E. Alliez and M. Lazzarato, *Guerres et Capital* (Paris: Éditions Amsterdam, 2017; translation forthcoming, Semiotext(e), 2017).

2. Cf. G. Arrighi, *The Long Twentieth Century: Money, Power, and the Origins of Our Times* (London: Verso, 2009), 71: 'If we designate the main thrust of British hegemony as "imperialist," then we have no choice but to designate the main thrust of US hegemony as "anti-imperialist".'

war machine of capital. To sum it up, with Kissinger: 'the word *globalisation* is really just another way of naming the role played by the US'.

Cybernetics of the Cold War

Not only does the Cold War mark our entry into the cyborg age of cybernetic communication and control; it is itself a kind of cyborg, in the sense that it harbours in its grey zone the Great Transformation of the war machine of capital by the *feedback* of all the 'information' of industrially and scientifically organised total war, with the latter thus becoming the model for the development of a (*non-*)*peacetime* economy. From studies on the shooting of anti-aircraft cannons and their automation leading to the idea of retroaction (and of the servo-mechanism), all the way to the digital simulations necessary for the construction of the atomic bomb, cybernetic thinking is not only born of war—it extends it *by all means*, in the management of a virtual-real planetary war that amounts to a permanent mobilisation and modelisation of a society submitted in its entirety to a calculus of optimisation (in good American language: *getting numbers out*). No science fiction here,[3] since the automated factory is, alongside the computer that 'calculates' the best strategy to win a nuclear war, the other entity in the cybernetic scenario. It is this constitutive relation between the machine-to-make-war and the machine-to-produce that gives us cybernetics in its modern sense (constructed on the basis of the Greek *kubernêtiké*)—the cybernetics of the machine-to-govern and of the *capitalistic machination of the government of men*. It governs both the management of war and the industrial management of a society as a whole (including the systems of public health, urban development, organisation of domestic space, etc.), a society whose 'dynamics we aim to understand and control using new instruments derived from the formalised engineering sciences' and techniques of management (understood in the widest, logistical sense, for there is no longer any 'real' difference between technics and logistics, hardware and management).[4] It is the war machine of capital that

3. We might think of Norbert Wiener's warning: 'If the notion [of cybernetics] merely pleases you by its romantic name and its science-fiction atmosphere, keep away from it' (N. Wiener, 'Automatization', in *Collected Works*, vol. IV [Cambridge, MA and London: MIT Press, 1985], 683).

4. D. Pestre, 'Le nouvel univers des sciences et des techniques: une proposition générale', in A. Dahan and D. Pestre (eds), *Les Sciences pour la guerre (1940–1966)* (Paris: Éditions de l'EHESS, 2004).

is the motor of this *science of organisation* and of the *operational research* that tends to abolish disciplinary boundaries, producing hybrids between 'pure' mathematics (which seeks to *fundamentalise* itself), hard sciences (with their monumental equipment which must be shared—the birth of 'Big Science'), engineering and social sciences (under the cosh of 'behavioural sciences' and of cognitive psychology: *behaviourism*). Promoted by the war of applied sciences that had just been won,[5] it is now the engineering of complexity that passes between (sciences of) Nature and (of) Society, with the invention of polymorphous tools constructed on the basis of mathematics, logic, and computers.[6] Their modalised and highly formalised approaches bore the names of 'operational research', 'general theory of systems', 'sequential analysis', 'mathematics of decision', 'game theory', 'mathematical theory of optimisation', 'cost-benefit analysis'.[7] What followed was a first form of *transdisciplinarity* (between logicians, mathematicians, statisticians, physicists, chemists, engineers, economists, sociologists, anthropologists, biologists, physiologists, geneticists, psychologists, game theorists, and operational researchers coming directly from the military domain) which would be favoured and financed by the American army (think tanks such as the RAND Corporation, justly considered to be 'the institutional touchstone of the Cold War in the United States',[8] Summer Schools, Universities) in constant conjunction with the large companies that it placed under contract, directing their development (the economy of innovation). It is thus a

5. See V. Bush, *Modern Arms and Free Men: A Discussion on the Role of Science in Preserving Democracy* (New York: Simon and Schuster, 1949), 27: 'The Second World War was [...] a war of applied science'. During the war, Vannevar Bush was director of the Office of Scientific Research and Development (OSRD) which had placed under military contract, without integrating it into the army, the American 'scientific class' and the most prestigious university research laboratories (MIT, Princeton, Columbia, etc.). As a result they saw an unprecedented growth.

6. See W. Weaver, 'Science and Complexity', *American Scientist* 36 (1947). A Mathematician, 'science manager' and director, since its foundation in 1942, of the Applied Mathematical Panel (AMP) which was a department of the National Defense Research Committee (NDRC), Warren Weaver would be closely associated with the creation of the RAND Corporation. RAND is an acronym for 'Research ANd Development'. This first postwar think tank was founded by the US Air Force, with John Von Neumann playing a central role.

7. Pestre, 'Le nouvel univers', 30.

8. R. Leonard, 'Théorie des jeux et psychologie sociale à la RAND', in Dahan and Pestre (eds), *Les Sciences pour la guerre*, 85. On the matricial function of the RAND Corporation in regard to the montage and handling of the Cold War, see A. Abella, *Soldiers of Reason: The RAND Corporation and the Rise of American Empire* (Boston and New York: Mariner Books, 2009).

matter of an *entrepreneurial transdisciplinarity* wherein researchers, although directly subsidized by the military apparatus,[9] are encouraged to assemble 'networks of technologists, funders, and administrators to see their projects through'.[10] What also follows from this is a new mode of *transversal govern-mentality* of the whole of society which succeeds in making the production of science and the science of production 'communicate', within the factory, only by 'factoryising' citizens-consumers according to the same procedural principles: the optimisation of control (through the regulation of an open system that takes the factor of uncertainty into account) and the extension of the domain of the circulation of 'information'. So that, at this twofold level, which involves the constitution of the *General Intellect* of Capital imposing 'cybernetics' as the metaphysics of a 'Theory of Everything' (Andy Pickering) informed by the computer, the Cold War gives rise not only to an experimentation on the planetary scale, in a global epistemology of the Soviet enemy based on its *simulation: it is the most intensive possible strategy for the rational continuation of total war*, one defined by the indivision of the 'total internal product' between the military and civil domains, and by its incompatibility with any kind of *laissez-faire*. All of which comes down to saying that the Cold War is an American project of the globalisation of social control driven by a cybernetics of the population.

For this 'internal production', this 'interior' which has proved its capacity for worldwide projection, is that of power that emerged victorious from the war at such an inordinate scale on the military, industrial, technological, financial, etc. levels, that it marks the end of European supremacy and of its classically extensive forms of imperialism. The postwar world is in ruins. If the wave of decolonisation well underway in a Europe in full social upheaval ('property is collaboration') serves to stimulate the new forms in which the global function of American power must clothe itself, at home, with the question of the demobilisation and the reconversion of the economy, this same power must confront the worker power that emerges from wartime 'full employment'. Coinciding with the emergence of the 'black' and 'minority' questions (*racial wars* of *internal decolonisation*), and with the 'problem' of the place of women

9. During the immediate postwar years, the Office of Naval Research (ONR) was to rapidly become the most important body for research funding in the US.

10. F. Turner, *From Counterculture to Cyberculture: Stewart Brand, the Whole Earth Network, and the Rise of Digital Utopianism* (Chicago and London: Chicago University Press, 2006), 19.

in society following their presence en masse within the factory (a *war of the sexes* for wage equality which threatens to have repercussions on the domestic economy),[11] the proliferation of strikes poses acutely the question of the transduction of *warfare* into an anti-communist *welfare*. To achieve the conversion of the 'destructive forces' mobilised by the sciences and industries of death into the 'productive forces' of the American Way of Life (the welfare-world of mass consumption that will roll out the virtuous circle of wealth and power), the subjective conversion of a militarised population socialised by the experience of total war into individualist workers—a conversion that is supposed to lead to the egoist maximisation of *homo economicus* to the point of optimal tangency for the system between consumers and producers—must be integrated into welfare. The question of social production and of the work of the reproduction of the worker himself lies right at the heart of the new cybernetic strategies of the war machine of capital. It will have to invest as never before the 'family unit' and the 'feminine condition', which is not for nothing the very *subject* of the famous 'Kitchen Debate' between Richard Nixon and Nikita Kruschev in 1959. The debate took place in Moscow, in the setting of an international fair where the American Pavilion consisted in a six-room model home with all mod cons, supposedly presided over by a particularly 'feminine' housewife.... The war of missiles ('the missile gap') is doubled by a 'gendered' war of commodities ('the commodity gap') which Nixon's rhetoric brings to the foreground: 'For us, diversity, the right to choose [...] is the most important thing. With us, there is not one single decision taken above by a manager [...] We have numerous different factories and numerous different sorts of washing machines, *so that housewives have the choice* [...] Wouldn't it be better if competition bore upon the relative merits of washing machines rather than the power of missiles?'[12] The theory of 'rational choice' thus passes by way of consumption, which is no longer the frontier of a future of peace and prosperity, but the limning of a present outlined, *designed* on the domestic front of the Cold War/Peace by the white line of electro-housework products.

11. 'Women demand much more than they used to', writes Selma James, 'A Woman's Place' (1952), in *Sex, Race and Class: A Selection of Writings (1952–2011)* (Oakland, CA: PM Press, 2012).

12. *New York Times*, 25 July 1959 (emphasis ours); cited and discussed by Elaine Tyler May in *Homeward Bound: American Families in the Cold War Era* [1988] (New York: Basic Books, 2008), 20*sq*.

The importance of communication owes to the fact that one must 'sell' this product—a 'characteristically American' one according to the title of the bestseller published in 1949 by a Harvard philosophy professor, Ralph Barton Perry—as an enterprise consolidating, on the basis of the couple, an 'aggregate of spontaneities' into a 'collective individualism' (two expressions of the same thing) whose truth is that of a 'scientific humanism' that amounts to the *social engineering of freedom itself* (Lyman Bryson, in another successful academic work published two years after and soberly entitled *Science and Freedom*).[13] The arms race that had enabled a Keynsianism of war against the USSR reconfigures *welfare* into a *war of communication*, which contributes in its turn to the positing of the Intellect as an 'instrument of the national cause, a component of the "military-industrial complex"'[14] whose power will then be gauged by the quality of its washing machines.

The development of *human capital* plays its part within this process via the integration of civil and military resources into a scientifico-academic military-industrial complex that promotes *Science* to the rank of an *endless frontier*, as in the manifesto-title of a 1945 report by Vannevar Bush (*Science, the Endless Frontier*), immediately reprised by General Eisenhower in a 1946 memorandum:

> The armed forces could not have won the war alone. Scientists and businessmen contributed techniques and weapons which enabled us to outwit and overwhelm the enemy. [...] This pattern of integration must be translated into a peacetime counterpart which will not merely familiarize the Army with the progress made in science and industry, but *draw into our planning for national security all the civilian resources which can contribute to the defense of the country.*
>
> Success in this enterprise depends to a large degree on the cooperation which the nation as a whole is willing to contribute. However, the Army as one of the main agencies responsible for the defense of the nation has the duty to take the initiative in promoting closer relations between civilian and military interests.

13. Cf. F. Turner, *The Democratic Surround: Multimedia and American Liberalism from World War II to the Psychedelic Sixties* (Chicago and London: University of Chicago Press, 2013), 157–9.
14. C. Kerr, *The Uses of University* (Cambridge, MA: Harvard University Press, 1963), 124.

It must establish definite policies and administrative leadership which will make
possible even greater contributions from science, technology, and management
than during the last war.[15]

At once militaro-civil and civilo-military, the permanent technological war there-
fore cannot but favour a global, systemic approach that integrates new tech-
niques of managerial management of the social into the *software* of *public*
welfare governed by a state that is not so much administrative as 'pro-minis-
trative' (a 'pro-ministrative state', according to the concept of Brian Balogh).

The Cold War's systemic stroke of genius that would govern its *C3I ration-*
ality (*command, control, communications, and information*), made possible
by the 'fission of the social atom',[16] would be the invention of a 'strange grey
zone which is neither peace nor entirely war':[17] this extreme *situation* where
all forms of social subjection will be made to depend *directly* upon a machinic
slaving to the system as such, with the latter affirming its immanence to the
axiomatisation of all of its models of realisation according to purely functional
relations that render them infinite in principle. Or, in Deleuze and Guattari's terms:
the axiomatic is immanent in the sense that it 'finds in the domains it moves
through so many models, termed *models of realization*'.[18] Thus in our view there
is no 'tension' between the will to axiomatisation characteristic of the Cold War
and 'these practices first of all developed under duress, far more pragmatically,
that were afterwards to be extended, broadened, formalised, theorised'.[19] Here,
on the contrary, we touch upon the *axiomatic motor* of the transdisciplinary
practices put to work in the laboratories of the Cold War (a *cold transdiscipli-*
narity). Through the Cold War, Capital's war machine will be able to develop
the immanent axiomatic of a new capitalism, that of 'man-machine systems', an
axiomatic that imposes a system of generalised slaving that assumes control

15. General Dwight D. Eisenhower, *Memorandum for Directors and Chiefs of War Department,*
General and Special Staff Divisions and Bureaus and the Commanding Generals of the Major
Commands. Subject: Scientific and Technological Resources as Military Assets (1946).
16. The expression is Talcott Parsons's.
17. Letter from W.D. Hamilton to George Price, 21 March 1968.
18. Deleuze and Guattari, *A Thousand Plateaus,* tr. B. Massumi (Minneapolis, MN: University of
Minnesota Press, 1987), 454.
19. A. Dahan, 'Axiomatiser, modéliser, calculer: les mathématiques, instrument universel et
polymorphe d'action', in *Les Sciences pour la guerre*, 51.

of a subjectivation 'impl[ying] processes of normalization, modulation, modeling, information that bear on language, perception, desire, movement, etc., and which proceed by way of microassemblages'.[20] In this sense the Cold War is primarily and above all a *war of subjectivation*, accompanied by what has quite rightly been called a veritable 'behavioural revolution'. It will be synonymous with an unprecedented state intervention—a *deterritorialization of the state* which deterritorializes, mediatises, and axiomatises the state itself by placing it within the network of the entire socius—through which *peace becomes synonymous with war* in a 'retroaction' of the epistemology of the external enemy onto the ontology of the internal enemy which extends the imaginary field of the global proposition of the Cold War.

Hence the televised 'situation comedy' invades American living rooms at the same time as a series of ever more perfected 'situation rooms' are constructed in the basements of the White House. The 'situation' will be rooted in the emergent American behavioural sciences linked to the rationality of the Cold War[21] and to its explosion of 'experts'. It will also bring into communication under one unique term—that of *containment*—the psychology of the middle classes (the concern with 'containing' its emotions, 'securing' its home: *domestic containment*) and the strategy of the 'containment' of Soviet power.[22] The proponents and consequences of the situation are summarised in the anticipation of Warren Weaver, eminence grise of Operational Research (OR), 'Grandmaster Cyborg', and 'creator of transdisciplinary research networks': 'The distinction between the military and the civil in modern war is [...] negligible [...]. It may even be the case, for example, that the distinction between war and peace is now obsolete'.[23]

The Montage of the Cold War

'We can express the problems of the US in two words: *Russia abroad, labor at home*'[24]—this was the declaration of Charles E. Wilson, former Executive

20. Deleuze and Guattari, *A Thousand Plateaus*, 458.
21. J.L. Klein, R. Lemov, M.D. Gordin, L. Daston, P. Erickson, T. Sturm, *Quand la Raison faillit perdre l'esprit. La rationalité mise à l'épreuve de la Guerre froide* (Brussels: Zones sensibles, 2015), 148.
22. See Tyler May, *Homeward Bound*, chapter 1.
23. W. Weaver, cited by P. Mirowski, *Economics Became a Cyborg Science* (Cambridge: Cambridge University Press, 2002), 210; 169sq on 'Warren Weaver, Grandmaster Cyborg'.
24. See D.F. Noble, *Forces of Production: A Social History of Industrial Automation* (Oxford and New York: Oxford University Press, 1984), 3.

Vice Chairman of the War Production Board, at the time in charge of the War Department Committee on Postwar Research, and future director of the Office of Defense Mobilization during the Korean War.[25] Wilson was president of General Electric when he uttered this phrase, whose entirely strategic concision no doubt owes to the multiple roles played by the subject who spoke it, and who in all evidence knew twice over that of which he spoke. To the point where we might go so far as to evoke a 'General Electric'[26] to highlight the militaro-industrial montage of the subject of enunciation who is about to declare a symmetrical war on the twofold external and internal front on the horizon of the Cold War which programs it as such. Although the phrase comes from the mouth of one of the enterprise leaders of scientific-industrial research in a highly strategic sector for the armed forces, it is the economy of the Cold War as a whole that must be redefined as a consequence: 'Russia abroad, labor at home'. Otherwise, according to a perspective which is postcommunist as much as postcybernetic, we would be forced to agree that the Cold War's role would have been, 'from the current point of view, [...] really secondary' to the 'New Deal for the world' which will deploy its power, even in the postcolonial transformation of the third world, 'less through military hardware and more through the dollar'.[27]

But can the one be *quite so* easily separated from the other in the new forms of affirmation of American power and of that *managerial revolution* which Orwell associates with a 'cold war', an expression he invented in 1945? The argument reads as follows: 'It is likelier to put an end to large-scale wars at the cost of prolonging indefinitely a "peace that is no peace" [...] by robbing the exploited classes and peoples of all power to revolt, and at the same time putting the possessors of the bomb on a basis of military equality'.... Here there is a twofold, internal/external, dissuasion whose articulation governs the Cold War as new global mode of the management of 'conflict' constitutive of the 'period'. The Cold War is not *coextensive* with but is *constitutive* of a *globalisation of civil war* that tends to become autonomous (for the exploited classes and peoples

25. Which would give him the upper hand over federal economic policy as a whole.
26. 'Electric Charlie' had immediately recruited as vice-presidents of GE two other officials from the War Production Board: Ralph Cordiner, who would succeed him as the head of GE, and Lemel Boulware. The most prestigious publication of GE was entitled *General Electric Forum, Defense Quarterly*, and is subtitled '*For National Security and Free World Progress*'.
27. M. Hardt and A. Negri, *Empire* (Cambridge, MA: Harvard University Press, 2001), 246.

that one would deprive of all power do indeed revolt, throughout the world), and of the 'management' of this war in an unprecedented form of *military security* produced by 'a tacit agreement never to use the atomic bomb against one another'.[28] It is this ecologistic understanding that is supposed to avert any possibility of 'going to extremes', where the extremity is no longer the limit (in the political, Clausewitzean sense) but instead the delimitation of an imperial and planetary arena whose tendency is toward the *duel* and the invention of a new type of government of populations (1984)[29] This clairvoyant analysis (isn't there something very Orwellian in Virilio?) is such that we would be forgiven for forgetting that the first Soviet atomic bomb (A-bomb) was tested in 1949—that is, four years *after* the publication of Orwell's article, two years *after* the 'Truman doctrine' of *containment* brought the expression *Cold War* into common parlance. Which serves to relativise the imminence and the *reality* of the Soviet danger (in short: Stalin was in no doubt as to American economico-military hegemony; he understood well the 'message' of Hiroshima, and after the war would adopt a *defensive* position), at least according to the language used by President Truman in his speech to Congress in March 1947: 'I believe that it must be the policy of the United States to support free peoples who are resisting attempted subjugation by armed minorities or by outside pressures.' The disjunction ('armed minorities or outside pressures', 'direct or indirect aggression', etc.) here plays the role of a veritable *inclusive* synthesis: it does not close down its terms, it announces and enunciates the *illimitative* character of the Cold War strategy as a principle of transformation and of the *(re)production of the enemy* through totalising and *totalitarian* transfer. This is the thesis of communism as the new fascism: 'Totalitarian regimes imposed upon free peoples, by direct or indirect aggression, undermine the foundations of international peace and hence the security of the United States'.[30] *Hot Hitler* and *Cold Stalin*.

In a series of articles entitled 'The Cold War' and published in the same year, Walter Lippmann interprets the politics of containment quite differently. He begins

28. G. Orwell, 'You and the Atomic Bomb', *Tribune*, 19 October 1945.
29. Published in 1948, *1984* (1948 'inverted') telescopes Americanism and socialism so violently that the book has the rare privilege of having been at once denounced in the US and prohibited in the Soviet Union.
30. 'President Harry S. Truman's Address before a Joint Session of Congress', 12 March 1947, <http://trumanlibrary.org/publicpapers/index.php?pid=2189>.

by expressing surprise at the exclusive reference to the 'communist revolution' and to 'marxist ideology' as explanations for the supposed expansionist conduct of the postwar 'Soviet government', when the latter respects the spirit of the Yalta Accord, founded on the position of the Red Army and the importance of its contribution to the defeat of Germany and Japan: 'It is the extraordinary power of the Red Army, and not the ideology of Karl Marx, that permitted the Russian government to push back its frontiers'; and even then, he observes, in a way *essentially limited* to the restoration of the 'tsarist' sphere of influence and 'compensation' for the territorial losses of 1917–1921.[31] The USSR thus behaved as would that other great continental power, whereas the USA developed a strategy so unorthodox ('a strategic monstrosity') that the diplomatic routes leading to a *pax vera* seemed to be undermined in advance. Whence the solution proposed by the 'famous American publicist',[32] calling for a retreat of *all* non-European armed forces out of Europe so as to respect Stalin's commitment not to integrate the Eastern countries into the USSR…. In short, what Lippman foregrounds is the *phase shift* of the American Cold War strategy, if we consider *only* the problem 'Russia abroad'. All the more so in that, given the dissolution of the Komintern in 1943, the dissolution of the American Communist Party in 1944 (after which the members of the CP-USA would move from a pro-strike to an anti-strike position, in the interests of the war effort),[33] Stalin's pressure on the Greek and Yugoslav communists to conserve the monarchy, and the protests of English communists against the dissolution of the coalition government on the eve of war, no one could any longer be unaware that Stalin had, in Eric Hobsbawn's words, declared a 'permanent goodbye to world revolution'.[34]

Despite the shared warlike rhetoric, and the apocalyptic tone adopted by the US alone, the primary characteristic of the Cold War, as Hobsbawm recalls,

31. W. Lippman, *The Cold War: A Study in US Foreign Policy* (New York and London: Harper & Brothers, 1947). The argument may be based on the famous 'Moscow cable' sent by George Kennan. The American chargé d'affaires foregrounds the Kremlin's 'feeling of insecurity' and the importance of 'Russian nationalism'.
32. According to Léon Rougier's presentation opening a lecture by Walter Lippman held in Paris 28–30 August 1938. This lecture has often been presented as the primal scene of 'neoliberalism' (the term is used by Rougier but does not win unanimous acceptance).
33. 'Communism is the Americanism of the twentieth century', exclaimed the president of the American Communist Party, Earl Browder.
34. E. Hobsbawm, *The Age of Extremes: The Short Twentieth Century (1914–1991)* (London: Abacus, 1994), 168. The global socialist revolution is abandoned in favour of national independence.

was paradoxically defined by the objective *absence* of the imminent danger of world war and the rapid mutual recognition of a *certain* 'balance of power' according to, *grosso modo*, the 1943–1945 lines of demarcation. From 1951, when Truman relieved of his command General Douglas MacArthur, who had wished, even if it meant using the nuclear weapon, to extend the Korean War to the Chinese territory (which became the People's Republic of China in 1949), up to the 1970s, via the crushing of the workers' insurrection in East Berlin (in 1953, the year when, nine months after the Americans, the USSR announced their own hydrogen bomb), and then the Hungarian (1956) and Czech (1968) revolts, also defeated by the Soviet tanks, the Cold War between the two superpowers increasingly takes on the allure of a *Cold Peace*[35] held in place by the (entirely relative) equilibrium of nuclear terror[36] on populations constrained to 'choose their camp' ('two world camps', bipolarism). One thinks here, of course, of the Soviet anathema against 'Titoism' and of the reciprocal advantages to be had from the repression of any kind of 'democracy from below' in the Eastern countries;[37] but also of the Cold War strategy as a means to impose American hegemony on its allies by way of a reorganisation of the world-economy toward a *globalisation* that could no longer be satisfied with the restoration of the 'classical' politico-military forms of the *balance of power*. After the failure of the 'phantom politics', following which the Soviet Union, strategically encircled, was bound to fall, the *high-tech* arms race (the H-Bomb, Strategic Air Command) was oriented toward a strategy of 'massive retaliation' (1953–1960). Supposed to eliminate the possibility of a limited attack with conventional means, it aimed above all to limit the risks attached to *American* neocolonial military expeditions into the coldest zone of the first Cold War: 'It is not a good military strategy to have ground forces engaged permanently in Asia, because this deprives us of any strategic reserve [...] So as to gain the necessary *stamina* to assure *permanent security*, it was imperative to make changes'.[38] A Soviet reterritorialization of

35. Ibid., 226–228 ('[...] until the 70s [the] tacit agreement to treat the Cold War as a Cold Peace held good'). The term *Cold Peace* was used in the 1950s.

36. It was only in the mid-1960s that the Soviet nuclear arsenal represented a technologically credible threat to American territory.

37. As Castoriadis wrote in 1976, there was 'little doubt that Reagan and Brezhniev were in agreement over Hungary' (C. Castoriadis, 'La source hongroise', *Libre* 1 [1977]).

38. Speech of the Secretary of State John Foster Fulles before the Council on Foreign Relations (12 January 1954) (emphasis ours).

the American deterritorialization. Here the American administration claims to make a 'permanent' decision between its 'nationalist', i.e. narrowly *geopolitical* interests, oriented toward Asia, and its *global* 'internationalist' ambitions oriented toward Europe, and to seat the logic of the Cold War firmly on an (exclusively) *strategic* basis. Although the American administration would be incapable of sticking to this 'choice', the course was well and truly set: it would fall to *great-power management* to take charge of the geopolitics of the new imperialism.

In this passage from 'defence', which was still the basis of the original doctrine of containment, to 'permanent security', we touch upon the paradigm shift brought about by the Cold War/Peace: either the indefinite prorogation of a *peace which is no peace,* given the *strategic threat* of a war so ontologically absolute (*total* destruction, *universal* death) for all civil populations that the permanent war economy that it promotes is synonymous (in the West, the pace-setter) with a *reprogramming* of social life in its entirety—what Paul Virilio calls *endocolonisation*,[39] and which must be related to the obsessive question of *control* within a historical sequence where American capitalist supremacy is at first threatened less *abroad* (by the risk of a globalisation of the Soviet menace) than *at home*, at the heart of the 'international system of capital', by the explosion of workers' struggles and race war, their flames fanned by the tumultuous demobilisation of autumn 1945.[40] [...]

The Underside of the 'American Way of Life'

A synonym of democracy versus totalitarianism, the promotion of the *American way of life* lies at the heart of the *declaration of Cold War* by president Truman, when he makes explicit the historic global stakes of the new conflict: 'At the present moment in world history nearly every nation must choose between alternative ways of life'.[41] Something that would be rather banal (and merely a continuation of total war) if this 'life' did not bring the war of subjectivity under the aegis of a new form of governmentality that embeds the *social engineer-ing* of the mass psychology of military-industrial democracy into spheres well beyond the cultural *containment* of 'communism' so dear to Voice of America

39. P. Virilio, S. Lotringer, *Pure War* (new expanded edition, Los Angeles: Semiotext(e), 2008), 68.
40. It is the threat of mutinies that accelerated demobilisation—the tens of millions of demobilised soldiers representing 20% of the American workforce in 1945.
41. Declaration of President Harry S. Truman, 12 March 1947.

propaganda. Both *at home* and *abroad*, psychosocial engineering became the vector of the economy of control via the integration of consumption into the permanent technological revolution of the scientifico-academic military-in-dustrial complex and into the market—the two guarantors of the political democracy of Capital: 'security and challenge in the same breath' to that which could only present itself as a 'people's capitalism'[42] inevitably opposed to so-called 'popular' democracies (or a democracy of the people: a *People's democracy*)[43]—because the first fruit of the Cold War is the production of a *people of capitalism*. With 'imperialist' and 'totalitarian' communism in his sights, President Truman could declare in April 1950, on the eve of the Korean War: 'This is a struggle, above all else, for the minds of men.'[44] The most interesting part of his speech is the moment when he appeals to the unions *at home* to testify *abroad* to the reality of wage labour (=free labour) in the US: 'The story of free American labor, told by American trade unionists, is a better weapon against Communist propaganda among workers in other countries than any number of speeches by Government officials.' But in order for the trade unions to become the best agents of a *People's capitalism* and in order for 'labour' not to be a problem *at home*, Marx would have to be expelled from Detroit. This was in principle a done deal with the signing, at General Motors, of the Treaty of Detroit (1950) which would cement the 'Fordist' relation between production and mass consumption by linking wage negotiations to growth in productivity—the union thereby giving up any question of the sharing of wages (set as a function of an index of the cost of living) or of profits. And in the same blow, 'productivity'

42. 'People's Capitalism' is the title of a 'truth campaign' launched in 1955–1956 by a counsellor to President Eisenhower, Theodore S. Repplier, which took the form of an international exhibition. It would be presented in South America and in Ceylon. See L.A. Belmonte, *Selling the American Way: US Propaganda and the Cold War* (Philadelphia: University of Pennsylvania Press, 2008), 131–5. The cited phrase 'security and challenge in the same breath' is taken from a magazine article in *Collier's*, '"People's Capitalism"—This IS America'. The theme of a 'People's Capitalism' ((and the expression itself) is central to Nixon's contribution to the *Kitchen Debate* with Kruschev.

43. The term would itself be propagated as a détournement and a return of the role of the people in the 'bourgeois democracy' promoted by the 'capitalists of Wall Street'. On the American side, it was explained that one must reappropriate the word 'people', which had been 'kidnapped' by the Russians: isn't it the American word par excellence, which opens the US Constitution ('We, the people') and which is at the heart of the definition of democracy given by Lincoln ('government of the people, by the people')? See the speech of T.S. Repplier, 27 October 1955, cited by Belmonte, *Selling the American Way*, 131.

44. H.S. Truman, 'Address on Foreign Policy at a Luncheon of the American Society of Newspaper Editors', 20 April 1950.

became the 'indispensable lubricant to attenuate the frictions between classes and groups', as proclaimed in 1947 by the Committee for Economic Development through the voice of its director.[45] The magazine *Fortune* could thus with good reason celebrate the agreement as 'throwing overboard all theories of wage determination through political power and profits as "surplus-value"'. The union also accepted exclusive control of workshops by the directors (*management control*), which it supported in exchange for the company's contribution to a *welfare* (retirement contributions, health insurance) that was thus already well on the way to *accelerated privatisation* (*private welfare plans*), at the same time augmenting disparities in the labour market.[46] Meanwhile, the power of unions and worker militants was transferred in the direction of the national union, which alone had the power to negotiate with the top management of the company. Negotiations which would conclude most often with a contractual commitment not to strike (as was the case with General Motors, for a period of five years). Locked in by this corporatist productivism, where the most 'guaranteed' objective interests of the working class tended to identify themselves with patronal policy ('business unionism'),[47] and where the unions, for their part, reprised the anthem of 'security' in line with a Keynsianism become 'commercial' to the detriment of its redistributive credo, which survived only on the margins of a compensatory state, 'labour peace' is affirmed as the model of the union *at home* and *abroad*. For it falls to the Marshall Plan to 'sell' the Detroit Treaty for export as a model for (appeased) social relations and as a way to transition from European conflictual austerity threatened by social revolution to an American-style *society of (control by) consumption*. In short, 'what was good for General Motors was good for the world',[48] in a new world order that made

45. Cited by C.S. Maier, *In Search of Stability: Explorations in Historical Political Economy* (Cambridge: Cambridge University Press, 1987), 65.

46. See N. Lichtenstein, 'From Corporatism to Collective Bargaining: Organized Labor and the Eclipse of Social Democracy in the Postwar Era', in S. Fraser, G. Gerstle (eds), *The Rise and Fall of the New Deal Order (1930–1980)* (Princeton, NJ: Princeton University Press, 1989), 140–45.

47. A year after the merger of the two unions, the president of the AFL-CIO declared in 1956: 'In the final analysis, there is no great deal of difference between the things I stand for and the things that the National Association of Manufacturers stand for' (cited by F.F. Piven and R.A. Cloward, *Poor People's Movements: Why They Succeed, How They Fail* [New York: Vintage, 1979], 157).

48. L. Panitch, S. Gindin, *The Making of Global Capitalism: The Political Economy of American Empire* (London and New York: Verso, 2013), 84.

the 'reconstruction' of limitless intensive development depend on a capitalist accumulation deploying mass consumption as its principle of social regulation.

Once the process of production was placed under control of productivity, it was the 'modernisation' via consumption qua colonisation of everyday life that was supposed to orient the inflationist social pressure of 'full employment' toward the acceleration of production and commodity circulation (through the planning of demand) in an *Americanisation of the world*. The 'New Deal for the world' is thus *contained* in the commoditization/privatisation of 'life', which becomes the *subject* of Cold War expansionist policies of *containment* whose primary agents are the unions (and in particular the AFL-CIO) once the Taft-Hartley law has done its 'work'.[49] In which respect the Cold War would indeed be a 'psychological war' whose modernity can be gauged by the anticommunism that will have permitted (the war of) subjectivity to supplant the notion of class (struggle). 'The importance of the individual', a principal American value which one of the major documents of the Cold War posits as '*more vital* than the ideology that fuels Soviet dynamism',[50] would be ideologically translated into the terms of a *welfare of propaganda* combining 'free competition between companies, free unionism and limitation of state intervention' with the '*growing classlessness of our society*'.[51] In this hyperbole the classless society becomes the basic tendency of an economy placed in the service not of the state but of the people, who reap the benefits of capitalism by relying on the 'militant and responsible' forces of *free unions*. 'In a democracy, capitalism uses its forces not in a negative way, to keep down the masses or to exploit them, but to develop production, to create new ideas and new wealth'.[52] The *communism of capital* here takes on all the allure of an *auto-mobile conduct* placing into communication ('everything communicates!', the leitmotif of Jacques Tati's *Mon Oncle*)[53] every

49. In his 1956 article 'The Economic Situation in the United States as Compared with the Pre-War Period', Michal Kalecki argues that the unions are 'part and parcel of the armament-imperialist set-up' (in *The Last Phase of the Transformation of Capitalism*,[New York: Monthly Review Press, 2009], 96).
50. NSC-68. Report no. 68 of the National Security Council under the presidency of Harry S. Truman (14 Apri 1950, definitively approved 30 September 1950). Drafted by Paul H. Nitze, report NSC-68 bore the hallmark of the RAND Corporation's geostrategic anticommunism.
51. United States Information Agency Basic Guidance and Planning Paper no. 11, 'The American Economy', 16 July 1959, cited by Belmonte, *Selling the American Way*, 120.
52. United States Information Agency (USIA), *American Labor Unions: Their Role in the Free World*, cited by Belmonte, *Selling the American Way*, 124 (emphasis ours).
53. See Kristin Ross's excellent analysis in *Fast Cars, Clean Bodies: Decolonization and the Reordering of French Culture* (Cambridge, MA: MIT Press, 1995).

sphere of work, domestic life, and the domain of leisure, with the factory and the city suburbs linked together by that 'essential product of the capitalist market' (Debord) that is...the automobile. Driving out on a network of motorways that no longer has any centre except a commercial one, the automobile is not only the flagship product of a fordist factory-society (6.5 million units produced in 1950 in the US—that is, three quarters of global production); it is also the *vehicle* of the consumer society, of its machinic-mental apprenticeship and of the necessary training for its commercial mode of socialisation. For consumption is that private value par excellence that colonises the quotidian by taylorizing the domestic space, fitted out with technological innovations (so many civil applications of the research and development programmes of the 'military-industrial complex') and privatising/financialising its habitation. After all, how can you feel 'at home' without possessing a 'place of your own', without making that *lifetime investment* that doubles the economic function with a 'securitising [and] thus identitarian function'?[54]

The mortgaged credit of 'Mr and Mrs. America'[55] took up the baton of consumer credit and *enterprise welfare* by imposing the whole domestic economy of capitalism as the affective core (centred on the couple, marriage, children, *Family Life*) of capitalist democracy: *Democracy Begins in the Home, Home Is What You Make It, Building Community Through Family Life....*[56] To the tune of 'I'll Buy That Dream',[57] the nuclear family becomes simultaneously a refuge from the anxiety linked to the Soviet nuclear threat (*The Red Target is Your Home, The Sheltered Honeymoon*, etc.)[58] and the domestic relay of the financialisation of the economy. Hadn't the investment banks, which had massively invested in the private insurance, mortgage, and consumer credit markets, thereby proved their 'vital' role in the real economy and the development of *welfare* for all...?

54. Ibid., 146–7.
55. The title of an article published in the *Air Bulletin* of the State Department (12 September 1947) which would play the part of a permanent rubric for the activities of the USIA.
56. Some of the titles of bulletins conceived and distributed by the USIA.
57. A song from the film *Sing Your Way Home*, a great hit in September 1945.
58. With fourteen days of intimacy guaranteed by the anti-nuclear shelter where the honeymoon takes place, as reported by *Life* magazine (10 August 1959).

Amanda Beech

Cold World and Neocon Noir

The way in which Art has manifested a comprehension of its relation to negativity, or the question of 'the unknown', has produced a fairly consistent marriage of explicit strife and implicit satisfaction. In demanding that art must exit this bind, the question of how art might propose and insinuate itself as a kind of knowledge that can operate as a form of intelligence in the world becomes central. But can art operate as a kind of projection of the yet-to-be-known, can it determine what *should be*, without missing the point completely, overdetermining the demand for an emancipatory trajectory, and responding, ultimately, only with a deeper conservatism? Namely, a conservatism that would identify consciousness as an end in itself, secured in an ontological regression of a thought thinking thought, precisely because the means of consciousness are all we have available with which to think it. In lieu of any goal or telos, the task of art, if it is to be proposed as a form of intelligence, risks determining consciousness as a thing that can be pictured but not known. This pitfall would result in trivializing both a concept of the image, and the intelligence that thinks consciousness. This is because, in the former, the image is correlated to the limits of a kitsch form of heroically alienated subjectivity and, in the latter, consciousness will always *be limited*.

These issues become vital in the face of the prevailing narratives of (neo) liberalism that dominate the humanities, culture, and the political landscape today. In these narratives, the project of the understanding, and the hope that it might act as a hinge to project and plan a future, is stricken by ideological figurations of affectual presentisms, action-isms, activisms, and idealizations of contingency as chaotizing forces. Such positions serve to bear witness to, and satisfy themselves with, a mere survival of the non-redemptive space of the political, and thus occupy the horizon-less landscape of a noir-ish world: a terrain that is always in the dark; a world which, in its expressions of violence,

paranoia, and fragmentation in the face of the 'Cold World' of our contemporary condition, seems to manifest the failure of both reason and the imagination.

The term 'Cold World' refers to that which is irreducible to knowledge. But it also refers to what is yet to be known, and ultimately prompts us to think about how the intelligibility of alienation as a condition of knowledge and political action need not stand in contradiction to the ability to take seriously an orientation toward the future. In particular, the present discussion gives me an opportunity to think about how art has often claimed itself, incorrectly, to be a figure of this unknown. Art is the essential spirit of a Cold World entity, since in figuring the space in which intelligence is exhausted, it can evidence the limit capacity of human knowledge. And yet through this rupture that is both internal to and set against knowledge, art symbolizes *an idea*—namely, the idea that *something else* can exist, but, crucially, that this thing cannot have any *particular* qualities, for this future without design must be equally principle- and norm- free. Art in the face of a 'Cold World' with nowhere to go, no programme or principle, circles a general sense of the world to come, and it can only loop back to the terminal identity of a human spirit extrapolated as a painful expression of the complexity that it finds in the lived world. This becomes the very life of the human, a life that is irreducible to reason but which can be purchased through aesthetic experience at the level of sensation: Art is claimed as the real made manifest, in a kind of unquantifiable anarchic theism; it proposes itself as the truth of the negativity of consciousness through the affectual dimension of sense perception.

A cultural obsession with art's access to the real is central to Cold World politics. 'Cold World' is a term that stands for the alienation that we experience in relation to the complex world of big data, hypercapitalism, and the apparent impossibility of fathoming or understanding what this world is. Everything is just too complex, and is it we ourselves who have engineered this, making it ever more tragic to think about: we have produced our own alienation. As a coping mechanism, many thinkers and producers have reframed a world of cause as a world of affectual chaos, in naive forms of realism that narrate the political as a space of nature. Here the term 'Cold World' is instructive, since it enables us to discuss how we conceive of our relation to an abstract field of massive complexity—a field that is authored by us and yet seems to be beyond our

current capacities of intelligence and understanding. To picture and communicate our understanding of these abstractions, on the one hand, we have often portrayed ourselves as overcoming our alienation and confronting these putative unquantifiables as alien forms of force—a Cold War paranoia, perhaps. On the other hand, we imagine ourselves caught up within these systems, as hopeless entities caught in a world of chaotic contingency, where we merge with these power dynamics in the ecstatic libertarianisms of a horizontal delirium. Either way, these descriptions produce standard stereotypes. The alien is protracted in mirrors of ourselves as other selves...whether we are gods or atoms....

We can already see the triad of irreducibility here: the question of what constitutes human consciousness, the question of the contingent world in which we find ourselves, and the question of Art. All collude in one primary figure that is estranged from itself. Clearly, we need to understand these terms better.

Detective Noir

The heroes of certain types of detective noir can teach us a lot about how we see ourselves in these relations. Detective noir describes a mastery of the world through the deployment of intuition (the hunch), a commitment to justice, and empirical reason (proof). The world of noir is a world of archetypes, and even its characters, as vessels for these archetypes, find themselves on the cinematic screen cut up, slashed and dissected by light and shadow. Human and scene are taken together, indiscriminately cut up by shafts of harsh-edged architectural light forming another substantive materiality for cognition and the senses. Agents and players of the Hammett[1] kind are always already alienated, incapable of forming relationships, unable to identify common social bonds that might outlast the temporalities of pragmatic economic gain; they are alone, with no prospect of sensitive intimacy. The detective alone can act differently because he has a commitment to something beyond the conditions of the scene itself; in many ways, he is more isolated than others because of this—a different form of isolation that involves an overcoming of alienation precisely by living it. Noir characters live in a world above the law, a place where they can access

1. I refer here to Dashiell Hammett, author of the pulp detective novels that sprung from the American prohibition and depression era: *The Maltese Falcon*, *Red Harvest* and others brought us the alienated Continental Op. These books outlined the archetype of our hard-boiled noir heroes seen in the vista of the Hollywood noir movies of the 1940s.

and reside in a specific kind of alienation. Their world, on the face of it, seems claustrophobic because the dark is infinitely edgeless; and yet the detective is harnessed by something beyond the conditions of law, something that responds to principle, and is inscribed in a committed search for truth and justice that often requires a high body count. In the filmic world of Cold War 1940s noir, scores are ultimately settled, but the world at large remains irredeemable. The cost of overcoming alienation within the world is the production of a world of fragmented chaos; a kind of deconstructive violence that produces a world of competing heterogeneities.

We can see how these conventions of alienation play out in the more contemporary cultural genres that we might call Neo-Noir. There are of course huge differences between the tradition of LA cop-noir narratives and the types of action hero tales that are the mainstay of many Hollywood movies of more recent years; but despite this aesthetic difference, we're going to look briefly at how the detective genre, the very space in which knowledge meets alienation, has been transfigured in its journey from the Cold War narrative to the scene of the action movie genre.

The archetype of the action movie hero generally pursues his own brand of justice, a kind of law that is above the law that is known and written. The protagonist, who normally does not seek action but is compelled to it through external circumstances, goes beyond the everyday laws of policing, societal rules, and judicial governance to exercise justice. We can draw a line from the type of hero played by Humphrey Bogart in *The Maltese Falcon* to the Hollywood cop action movie, as a means to think the trajectory of knowledge, action, and alienation. The heroic identity of old school noir colours the world of the action movie detective in a specific way: although we see a shift within the frame, from the chiaroscuro of a noir sculptural space to the dynamic of time, speed, and mobilization in the action genre, as a thread running through both of them we see the absolute manifestation of a form of alienation *from the world*, but not from knowing. The protagonists of both genres share an agency for justice against a metaphysics of truth.

The heroes, or anti-heroes, of detective action movies are free from the world of legal or moral constraints, and live in a world where they act according

to their will and volition, apparently undirected by any external rules or principles. This is borne out in the lived world where, to all extents, it seems that they can do what they like. However, despite this abundance of freedom, strict codes organize their behaviour: it is always correlative to some sense of real justice, and is operated through a tacit and often a priori knowing of the truth. In other words, the question of the discovery of a criminal act, or the culprit, is not what determines the content and meaning of the narrative; instead it is how knowledge is proven that matters. Both this rule of justice and the nature of the criminal and/or crime are inscribed a priori, from the start. The narrative is only the means by which they are confirmed and condemned—something that has to be tackled with increasing creativity around the operations of this law as a performative, violent, and entertaining theatre. In the action hero genre the story is often mystery-free, and follows a unilateral direction, relentlessly pursuing its goal. The content of these films, largely defined by 1990s Hollywood productions such as *Die Hard*, but also manifest in later TV series such as *24*, promotes an image of agency as a driving home of various facts that are already given, in the given, and which remain uncontested throughout. The narrative is not interested in subjecting the world in which it finds itself to any sceptical interrogation or analytical scrutiny. In this format of the detective story, knowledge is written as a form of fate: it's just a matter of evidencing what we already know, in a vicious circle of knowledge and the image. The justice it portrays provides us with norms that construct an ethical space of action, but makes it impossible to enter the space of the construction of new norms. Our action-hero characters are nevertheless imbued with a specific identity of freedom where their actions bludgeon through 'everyday' constraints such as the code by which societal norms function. The infrastructural norms of the social are abandoned, our hero is blind to them. Cars can drive through buildings, gun stores can be raided—there is no such thing as no access because rights, territories, and property are ignored; a state of emergency that emerges at a psychological level spills into and over all forms of public life, in the name of justice. These characters traverse a causal reality and a contingent reality. They produce a parallel reality. A deep symmetry with anarchical freedom guarantees their ability to navigate the lived world as a game-style scenario, to master its

conditions and to overcome the obstacles that it puts in their path.[2] The everyday world presents obstacles that certainly exist and are noted as such—things are not easy—but obstacles are swiftly reduced to disposable constructions. The world is torn apart. Operating as an embodiment of an unknown or ungraspable reality, action is played out in the vitality of a sensory world. Thinking and talking are now exchangeable with the body language of kicks, swerves, and punches. There are no moments of reflection, no wondering or questioning whether the bad guys are really bad—instead, everything functions in a dynamic of cause, results, and production.

Whilst this agency operates as if blind to the cognition of any higher law, and posits a form of fatalism that would return us to the mythos of *Oedipus* (where agency is deflated precisely in the misguided and tragic belief that choice matters), the operations of power that we identify in these cases actually perform a type of transcendence that is reminiscent of our alienated noir detectives. Both determine an anarchic atheism; yet in both cases, what mobilizes life is a core commitment to a higher law that is now embodied as immanent to all action, in another theology. In these formats of pervasive violence, the moral codes that would preserve the social as we know it can only be secured by transcending them. Traditional neoliberal norms under threat by terrorism, gangster violence, the right, cultic left-wingers, and so on, must be protected against at all costs. In this transcendental life of brutal affect and drive, the detective mutates into a figure of militaristic force. The work of knowledge becomes the subterranean manoeuvres of 'Special ops', out there in public, in the name of conserving State, family, democracy, rights, the free world...but as this happens, as we have seen, the space that must be protected is also mutated into a territory organized by this new form of violence.

2. This also extends to the larger gamification of narratives, where episodes within films are highly predicated on another format for their existence, such as immersive theme park rides and video games. The format of experience acts sometimes as a heterogeneous fragment inserted within a more traditional narrative arc. In other instances, however, the film is entirely constituted by a series of fragments loosely tied together by a weaker, back-story narrative that is only trivially driving the direction of these episodes. This is exemplified in films such as *The Fast and the Furious*, where the detective character is purposively smuggled into the narrative play. Both the notion of a core narrative based on ethical rules and the idea that this character is in pursuit of knowledge are hidden from view to the point of non-existence. They act merely as a fragile architecture to situate the fragmentary episodic story.

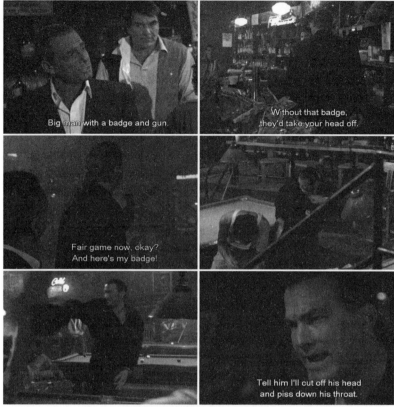

Out for Justice (Warner Bros., 1991).

Action-Noir and Pure Abstraction

A case in point is Steven Seagal's *Out for Justice* (1991, dir. John Flynn). In one bar scene where Seagal's character Detective Gino Felino is hunting for the bad guy Bobby Lupo who was connected to the gruesome death of a fellow officer, the amazingly verbal script, which employs the rhetoric of an excessive and even burlesque street violence, is equalled by the viscerality of the pool ball co-opted by Seagal as a makeshift nunchuck to devastate the lowlifes he is intimidating. Felino is responsive, quick, efficient, with the usual Seagal Aikido moves and a creative adhockery of the moment reminiscent of Jackie Chan (sans comedy). Before the main fight, as Felino winds up the action, he repeatedly speaks to the freedoms that he can exercise once he divests himself of the markers of repressive law, the gun and the badge. Felino is taunted by

the guys, who bait him with the challenge that, without these, he is weak and powerless. But of course, we know better, for it is in his freedom from these repressive symbols of everyday law that Felino is able to exercise a justice that gets results. By disposing of the law, Seagal manages to exert another force of law, one which has no order. What replaces this is another economy, one of violence, as fragments of bloody teeth spray across the pool table baize.

Crucially, this confluence of creative action, godlike power, and a strong play of alienation, is devoid of consciousness of the kind that orders action. Here the subject is separated from the conditions of empirical state law, and has overcome alienation through a transcendental physicality that bears out no relation to any alterity. He engages with the world as one system and machine, determining his action and his fate.

Turning in another direction, we see this process repeat itself: perhaps surprisingly to some, similar stories are to be found in the world of Art. Green-bergian Modernism championed the idea that the creation of a blank austere abstraction was the access point to reality that would be the apotheosis of a genealogy of the image. A Jackson Pollock action painting provides us with that specific correlation between ourselves, art, and the real. To move from the action movie to the world of the action painting may seem a crude analogy, but the purpose here is to suggest that it is possible to draw a line from the primacy of action as a space of cognition-in-action, to the space of action as the means by which art can occupy and present to us the conditions of a culminative present—a present that inherits history and surpasses it. The real is a place where representation is neither necessary nor possible. We embrace the real through a kind of libidinal intensity that is not so far from the kind of desiring forces that administrate the Steven Seagal hero mode where, as we saw, justice is an unwritten code, criminals are already known, and the action of justice is a performance in the world, a kind of acting-out of the always already known.

Whist our filmic example dates from the 1990s, this is clearly a convention that has persisted in recent film. *Lucy* (2014, dir. Luc Besson) offers the story of a woman who exceeds the capacities of ordinary human logic. This higher state of cognition is embedded within the body itself as site, and again the aesthetics of martial arts lead the way in the defining aesthetic of this sense-based materiality of action and thought.

Another very typical and perhaps overused example is *The Matrix* (1999, dirs. Lana and Lilly Wachowski). Neo makes it through the world of ordinary life to meet the space of its metaphysical organization. In doing so, he gets to merge with the system of the program itself. Although Neo is another hero deploying action by way of the typical mix of guns, martial arts, and so on, these skills are first and foremost directed by a cognitive transcendence. This recalls the drug-induced scene of transcendence in *Lucy* (unlike Neo, Lucy doesn't get to choose; and her very name, as opposed to the notion of the new implied by 'Neo', refers to the first known female evidence in archaeology, the oldest hominid ever discovered. To this extent, Neo represents the revolution of a chosen consciousness, while Lucy is the figure of an accelerated evolutionary biology). After being forced to take the mind-expanding drugs, there is a becoming of something other, a form of rebirth, and the world is seen anew from another alienated perspective. To that extent, Lucy and Neo are inverted forms of 1990s-era action hero. Neo and Lucy's 'agency of the mind' consists in an access to the data that controls 'the all'—and this ultimately produces distinct worlds that mimic the politics of liberal escapist hopes. Their collapse back onto the real of power, however, never amounts to knowing it in its entirety; instead, they become part of it and play within the system itself. To overcome alienation, then, and to know 'the all' by sacrificing oneself to the space of the real, is simply to conjure another form of power that fantasizes about its ability to reprogram the system. But it cannot. This is a tragic model of knowledge where there is no real access to the real of the real.

In these three examples—the noir hero of action-detectives, artistic abstraction, and the noir hero of the concept—we see a similar desire: the desire to map ourselves into the real as a means to adjudicate the idea that there are some things that we will never know. And across all three we see the privileging of a highly individualistic antisocial, neocon, neo-noir aesthetic.

All three examples described here are fictions that we have engineered in contemporary culture and which tell us something about ourselves. Each fiction repeats the fantasy about an alien unknown that we overcome through becoming equal to it, and in each case this is primarily figured in the pragmatism of habitual intuitive expression. This is a metaphysical Truth dressed up as nature, exerting its force in the material world; the world warps around the actions of subjects

and knowledge as its own predestination. This means that the formats that we have discussed cannot resist sliding from an aesthetics of action as determined in the moment (where each mark made by Pollock on the canvas has a determined spirit and intensity) to a theory of fate (these marks, whilst producing an effect of determination, are not determined with any horizon or premise in mind beyond action for itself). Each of these fictions struggles to picture or to propose any kind of detective work, or what I would call a project of reason, that is legitimately working with something that is unknown, or yet to be known, without conjuring this notion of the unknown as a definitive object in a stage and state of fear; without picturing a reflection of a form of human darkness.

Because of this, the figure of the human as given in these fictions is one that maintains a transcendental distance from the quotidian reality of everyday life ; as such, the human who 'acts' or who appears to be decisive and free from doubt does so at the expense of a theory of the more than one, or what we could refer to as community. Their connection with the real takes place at the level of a deep interiorized psychology, in back street bars, or in the fantasy space of the autonomous art-world—all places constructed to exist beyond the reach of the law. When these principles play out in the social, then we have to be both vigilant and suspicious, because we might find ourselves on the other side of their 'justice', in a world of proto-fascistic proportions. Although the figures of knowledge, agency, and action triangulate in the space of the real, these fictions promote a naive and dumb Promethean pragmatism that forgoes the real work of thought, because it believes that action supplants representation. Is it possible to articulate this form of mastery and alienation in another way? Are we capable of traversing a more complex understanding of alienation today, and of reclaiming this Promethean-type character as something that can still be useful in approaching the task of agency and knowledge in the face of these archetypes of alienation?

Figuring Alienation

Our dominant abstraction, neoliberal capital, has often been figured in the form of an alien monster, one that we have to live with as a thing that we know and yet which is impenetrable to us. Problematically, descriptions of capital that approach thought through this form of negative autonomy return to basic descriptions of our knowledge, rather than comprehending it in its deeper

complexity, a complexity that includes us but one that cannot be mastered through self-consciousness alone. A naively produced form of capitalist realism risks perpetuating the core stability of these systems, precisely because it normalizes them as unknown, groundless, and unstable. In other words, a traditional leftist conception of neoliberal capital is to establish it as a form that refutes knowledge, because such a conception fantasizes that it is out of control in a radical sense. Capital becomes heteronomous nature, cast in the role of a contingent force. It acts as the absolute guarantor of a future that is yet to be known, for we cannot think beyond it; but at the same time this future is cast as indeterminate and beyond our control. This conception of capital foregrounds it as a figure of no figure—irreducible to the understanding—and it risks rendering capital as a grand and unrelenting fiction that is indispensable to defining the value of life. Therefore, we have to be careful about our disposition to configure the project of self-understanding as causally related to the mastery of capital, as well as figuring both the self and capital as irreducible to reason.

Fiction does not step in when intelligence leaves us. Rather, the fact that abstract fictions are woven into the fabric of the space of reason means that we must deploy more appropriate forms of fiction that enable and enact a project of reason, rather than describing reason as something that is presumed to be always already organized. In pursuing this task, we must be careful to distinguish self-narration from the explication of knowledge. This requires an understanding of the elision that is made between an art that explicates the understanding and an art that objectifies it, or between an art that articulates a view from human consciousness and an art that mirrors it as a terminal identity.

To undertake this task is to accept the relation between cognitive accounts of reason and the role of representation, and to understand that both have a necessary place in making art sufficient to the task of any detective work. This is not representation as we might traditionally conceive it, for this representation does not image the ground from which it springs, or the goal it aspires to, as a direct correlation. Instead this work of representation is a manifest form of thought that is generic. It has no genre in terms of a standard aesthetic experience to be reproduced or re-enacted. There is no reason why art should be bound to a form of dogmatic theism; but an art that seeks to engage with a

project of reason must require a metaphysics of its own process as a means to re-engage, from the site of alienation, with what the world *should be*.

What is irreducible to reason dwells as a real facet of alienation within a life that reasons. Jean-François Lyotard's text 'Every Political Economy is Libidinal' is informative here. Lyotard speaks to the problem of alienation and how it relates directly to culture and creativity. He complains vigorously about the phantasy of alienation, namely how alienation is proposed as the undoing of good liberal hopes that seek to reconcile the unified and real body that would service a protracted human agency, hopes that are often laid at the door of aesthetic experience to resolve.

He describes these theories as working 'towards a new vision of the world, towards a humanism of creators at heart similar to that of some big philanthropic American boss [...] towards a theory of generalized alienation which necessarily implied as a double a theory of generalized creativity—the only means known since Hegel and undoubtedly Jesus as well, of not being alienated without being God'.[3]

Lyotard's work asks us to understand the real condition of alienation without nurturing the aspiration to overcome it. Lyotard speaks to Marx here, since Marx believed '[i]n the phantasy, so powerful and constant [...] of a happy state of the working body, this happiness being thought as the self-unity of its parts'.[4] We can see this pictured in Rousseau's State of Nature as well; but here Lyotard argues specifically that our error is to believe incorrectly that unity existed in the first place, was lost under the duress of capitalist force, and must therefore be reconstituted or can be reconstituted in the future. The wrong-headed idea that redemption is the other side of alienation speaks to the examples discussed above, all of which develop a mythological mirror that identifies our collapse onto the real as a means to re-emerge as a transcendental individual harnessing the power of the real as a violence manifest in the world. More to the point, Lyotard's essay points to the direct political dangers of such thinking infected by the 'phantasy, not simply reactionary, but constitutive of Western theatricality, [of] believ[ing] that there were societies where the body was not

3. J.-F. Lyotard, *Libidinal Economy*, tr. I.H. Grant (Indianapolis: Indiana University Press, 1974), 118.
4. Ibid., 121.

fragmented.'[5] The other side of this fragmentation obviously underscores other problems—that is, the question of a life lived through alienation, as opposed to a life of alienation. A life of alienation dangerously inscribes a form of ironic surrender to the capitalist machine as the last chance of reason, one that sustains the utopianism of eschatology via identity formations whilst always already sacrificing a commitment to reason as a project. As such, a life that is lived as fragmentation is not a life either, or is not a life worth living.

This would demand that we understand reason with an expanded intelligence that refuses to hypostatize this abstraction. In other words, rather than turn complexity into poor art, or produce the mythopoesis of the non-political infinite as a symbolization of complexity, our first aim should be to re-vision reason itself. This is fundamental to any future-oriented exercise. Here we judge what appear to be complex images to be, in fact, cognitively simplistic pictures of our alienation. We eliminate the myth that it is enough for art to manifest itself as the living symbol of a redemption to come. This marks a strong distinction between an art that indicates its belief in the future and an art that applies appropriate methodologies adequate to the future.

Determination Against Fate

Leaving these narratives of unity and fragmentation behind, we can think alienation again. This is a recapturing of the coldness of the world, and an understanding of the ways in which alienation is necessary for the construction of thinking, and constructive thought. The role of culture then is to address its own possibilities, understanding itself as a set of images that are intelligible to the understanding, and in doing so to exceed the picturing of what it means to be human. This is to cancel the tradition that bases its sufficiency on the production of images that operate as both correlate and referent to the value of the human: first of all, the image as image—the concept of the image as a space that outlies rational intelligibility; and secondly, the matter of the image; the specifics of sense perception that read the meanings of the signs, colours, and codes that we come into contact with that serve in anthropocentric tradition to stand in for ourselves. No longer will the image as concept nor the thing that it pictures speak to what it means to be alienated or what it means to be free from alienation.

5. Ibid; 120.

The art that can capture this thinking must understand, as Lyotard emphasised, that there is no a priori coherent distinction between the charismatic intensities of a libidinal economy and the quantifications that subtend political economy. This means that we must understand our entrance into the field of constructive abstraction always within the site of representation, with the understanding that this does not imply an anarchic epistemology, but a field that has rules and norms which can be altered according to the instantiation and testing of new ideals. We will now examine how this notion of change occurs within conditional norms.

Adolf Grünbaum's essay 'Free Will and the Laws of Human Behavior'[6] speaks directly to the conditions for deterministic or causal behaviour: he revokes the argument that 'consciously directed human action is beyond the scope of scientific comprehensibility'[7] by arguing that causal determination is not opposed to free will, and that free will in itself is always already conditioned by circumstances. His theory positions a view of determinism against 'indeterminate libertarianism' and develops the idea that determinism does not guarantee the result of any predictive behaviour, although he does accept that humans demonstrate regularities enough that one should not assume that any idea of free will is opposed to laws. Referring to Popper and calling upon Sellars as a means to disavow both epistemic and logical predictability, he writes: '[...] the career of a deterministic system will not be completely predictable by a human or a computer if they themselves are constitutive of that system'.[8] The question of how it seems imperative for humans to feel and believe that they act freely in order for any act to take place meaningfully is central here, for it would seem, on the face of it, that if human action is viewed to be in accordance with norms, then it loses its capacity for unpredictability, the wildness that produces unknown futures. These unknowns make action meaningful, special, and different. When confronted with this argument from the side of norms, determinism would then fall into a basic conservatism, where the future is rendered futile, and life trivial, because they are hinged upon an already received knowledge. Therefore, both life in the present and the future are sacrificed to the machinery of fate.

6. In A. Grünbaum, T. Kupka (ed.), *Collected Works Volume 1: Scientific Rationality, the Human Condition, and 20th Century Cosmologies* (Oxford: Oxford University Press, 2013).
7. Ibid, 79.
8. Ibid, 80.

This conservatism is also violent, for if actions have causes, then subjects are freed from moral responsibility. The fear is that the value base of ethical injunctions that would support any emancipatory politics is surrendered.[9] But this view mistakenly premises freedom on an understanding of autonomy as a place where we can choose to have acted otherwise, and which accordingly premises moral agency on a cause-free universe. Grünbaum argues that freedom is not the historically produced feeling that 'things could have been different', since in fact autonomy understood as a feeling of freedom consists in acting in accordance with the strongest motives we have for action—and these are always in accordance with some regulatory norm.[10] According to Grünbaum, then, a theory of the 'inner self' that has been the standard bearer for pure indeterminacy can be rationalized, and even irrational acts can be understood as having causes. The question of predicting a future from reason that can guarantee the future is impossible, but this impossibility is not in itself a guarantee that there is no predictive behaviour. The question of how rules and norms are subject to change is crucial in this case, because, following Grünbaum, we know that there are causes for our actions and that actions can be explained, but at the same time, we cannot use this space of reason as an absolute ground from

9. Thomas Metzinger's *Ego Tunnel: The Science of the Mind and The Myth of the Self* (New York: Basic Books, 2009) outlines this anxiety. Chapter 8, 'The Consciousness Revolution', imagines universal recognition of the Ego Tunnel might develop a dangerous political landscape, and that the ego that conserves our self-model cannot survive without a bottom-line negative theology as a means to act as the support for this consciousness. 'More and more people will start telling themselves: "I don't understand what all these neuroexperts and consciousness philosophers are talking about, but the upshot seems pretty clear to me. The cat is out of the bag: We are gene-copying bio-robots, living out here on a lonely planet in a cold and empty physical universe. We have brains but no immortal souls, and after seventy years or so the curtain drops. There will never be an afterlife, or any kind of reward or punishment for anyone, and ultimately everyone is alone. I get the message, and you had better believe I will adjust my behavior to it. It would probably be smart not to let anybody know I've seen through the game. The most efficient strategy will be to go on pretending I'm a conservative, old-fashioned believer in moral values." And so on.' (214). Here, in the face of a global pedagogy that would prepare the ground for this revolution, society calls upon the 'ego tunnel' and it is reverted to as the thing that guarantees life in the political; the political is now a space of irony, backed up by systems that are useful yet false. The cat is never really out of the bag; instead, the ego tunnel suppresses this information in the name of the continuation of the familiar. It's not surprising how this picture sits easily within a Lacanian politics of repression and irony described by Slavoj Zizek. (March, 2017, UCLA, Los Angeles, *Negative Theology*). In this talk Zizek calls upon the figure of Santa Claus as the example of a fiction that is necessary to culture; a fiction that we understand as such, but which is nevertheless acted upon *as if* it is fully believed.

10. Grünbaum, 'Free Will and the Laws of Human Behavior', 88.

which to predict what happens next. To understand the way in which agency might be articulated by Grünbaum is to criticize the way in which knowledge as a project of emancipation has been abandoned in the strong advancement of the presentism and affect-based theory that offer us the action-oriented detective, for whom knowledge becomes subordinate to action *in the moment*. The action hero as decisive and yet indeterminist character leaves the role of cognitive power behind, and in so doing, it results in manifesting another fatalism because it cannot think beyond its own sense-being.

On reflection, we can see how art participates in this axis of libertarian theory, favouring melodrama over and above a rational approach to the systems in which we may engineer, build, and predict. This comprehension of indeterminacy is contradictory and regressive. It grounds a politics in the real as a unity of aesthetic expression and an indeterminate present that smacks of a charismatic modernity, collapsing together the a priori fragmented self and the indiscriminate future to come. We see a contradictory transposition of the real and the fictional self; a real indeterminate identity is produced as and in the constructs of fictive material; and the constructed self that is required to think this recedes into a kaleidoscopic real. Finally, a theory of art's politics as indeterminacy faces the contradiction that this is all written in the name of cause, albeit a cause that is abstract in nature. This form of commitment has to be abstract, since its claim is not for a politics, but for the maintenance of the political itself as open.

To understand how we might re-position a project of reason, it is essential that determinism refuse to hypostatize the unpredictability that is characterized by human participation in any predictive process as an anchor for its project. According to Grünbaum, the basis of such misunderstandings are that free will, constraints, determinism, and fate are fallaciously identified by the indeterminist as equivalents,[11] when in fact there are causes for both voluntary behaviour and actions that are seen to be compelled by other forces.[12] Given Grünbaum's argument, is it possible then that this deliberate estrangement from the politics of alienation (which identifies indeterminacy as ground) is capable of determining itself against these myths? How determinism is both a principle and a process is key to answering this question. A commitment to determinism as a specific

11. Ibid., 83.
12. Ibid., 93

rational principle for itself highlights the non-relation between determinism as principle and as action/process. If determinism argues that action is always already determined, then a consciousness that actions are determined does not necessarily correlate to any paradigmatic shift in actions themselves. A third element now arises for our consideration: the question of what is to be determined by action that is orientated through these principles, and the political dimension of this task, now emerges.

Reason and Cause

The political imperative that requires the identification of determinism to have real transformative consequences in the world invites the question of reason and its validity in this world of cause. Reason is understood as the ontological exercise that explains why things are the way they are and therefore establishes the grounds for our beliefs. Reason is required for the argument from the side of determinism, and is key to deposing the idealism that correlates free will to indeterminacy. However, in order to do so, it must exceed the space of causes that it explicates, since, if it does not, we might be lost within a regressive ontology of cause that reason cannot hope to articulate seriously. Furthermore, if reason persists with a claim to emancipation via the position of determinism, then this also seems contradictory.

Two fears are rehearsed here: Firstly, without a project of reason that is tied to emancipation and that is distinct from cause, judgements are made trivial, change is arbitrary; and secondly, if we are to sustain any project of emancipatory reason, then we risk re-inscribing indeterminacy. Another way of situating this dilemma is to say that determining reason as cause might equally fall back into the (neo-) liberal paradigms that we have targeted in this critique, paradigms in which reason becomes arbitrarily embodied within the space of actions, and where the space of language is idealistically foreclosed to any interface with its organizing principles (concepts). The question then arises and delivers a second fear: How can reason be taken as distinct from cause, without condemning reason itself as a form of irrationality, and understanding the operations of reason as being imbricated within the space of cause whilst being irreducible to it?

As we refer to the world of the artwork, we occupy the space of ordinary language. In art, we perceive concepts that are manifest in materials

that represent. These communicate *because* we employ common conventions, archetypes, and norms. It is accurate to say that any deterministic process, including art, contains self-reference—that is, that any intention to manifest another ontology is always determined from the place that makes this claim, and therefore imbricates a host of already existing ideologies, motives, conventions, and norms with which this claim will be developed. As such, the idea that art itself is to determine what art is, implies both the construction of another state, one that is posited as the way things *ought to be*, since determination is taken seriously, and the (often dissatisfactory) premises from which it springs, but which are necessary for judgement.

The impossibility of self-estrangement that is foregrounded by determinism allows us to situate another kind of alienation that is not privileged as transcendental aesthetic experience (thus inferring the limits of reason), or posited by a theory that explicates the limits of reason. Alternatively, this explication of alienation aims to demonstrate that it is a necessary process. Therefore, the necessity of self-reference is not indicative of, or equivalent to, the irreducibility of consciousness; and we can disentangle this recognition of the pattern-governed behaviour of human life from a discourse on alienation. This conceptualization means that the work of reason enters the field of cause as concept-image. It is the actualization of concepts in distinctive intelligible forms.

This articulation of reason and cause might enable us to think more functionally within the world of representations to produce concept-forms that rigorously intervene within the rule that has subtended the neoliberalist paradigm of free will. It is also noteworthy that this paradigm has confined and determined art as we know it, intrinsically undermining leftwing political authority. The alternative to this is another noir—but it is a seeing in the dark, in the space of non-exceptionalism. It requires an approach to alienation that utilizes rational judgement over the desire to collapse mind and body as affectual economy, or reason and cause as the negative theology of a life alienated.

The two factors of contingency that we have outlined in this case: (1) The impossibility of self-estrangement from the predictive process, or in other words the field of determinism; and (2) The fact that our predictions are not absolutely guaranteed to come to pass, should not invite a larger claim of an indeterminist ontology. As we have seen, this would simply reduce language to the status of

a trivial fiction. Instead we invoke a stratification in this world of cause, because there are legitimate distinctions between thought and action and because the work of reason, as we have argued, is solicited to produce a new concept of art.

Art, positioned as such, is therefore articulated as a form of conceptual representation purchased through the protraction of a scientific method. Together this concept-image as rational attitude sublates the fateful 'inevitabilities' of the indeterminist. This is a refusal to idealize alienation as nature or goal, since alienation is necessary but insufficient for any project of reason. It is here that the link between unreason and freedom, along with that between indeterminism and autonomy, are effectively broken.

Conclusion: Determining...

To rehearse the question: Is it possible that an artwork could realize this view of reason as *a process, a goal, and a content* when reason in and for itself begs the question of how reason externalizes itself and is without identity? How might we understand reason as an emancipatory project with horizons beyond the solipsistic task of encircling its own validity? Above we have described how an ontology of cause is a description made by reason, and that, whilst reasons have causes, reasons are not causes in themselves.

If we understand art as a predictive model for a future, then it firstly needs to internalize this duty to itself and manifest this as a didactic commitment to a *future* that will fully realize itself. Art must orientate actions toward a future that will inhabit the impurity of predictive behaviour without irony, with a commitment to the adequacy of this project of reason to a political landscape that will challenge the inequities of neoliberal capital. The future is not open, it is determined via belief-forming processes.

The task for a Cold World Art is to produce a different economy of an epistemic detective fiction that explicates reality; it understands the project of determinism as a call for the construction of non-trivial beliefs employing norms and goals that are regulatory but not identitarian in nature. Like the art of neoliberalism, it will not have a defining aesthetic, but it will behave differently; for this art goes to work with beliefs that are based on reason. A critical art that takes this up works in the field of representations-as-actions that do not rely upon empiricism as a ground to flee from the abstract indeterminacies of

(neo) liberal culture.[13] Instead, a generic and determining reason is opposed to a neoliberalist abstraction of indeterminism.

Again, what is this horizon? It is a comprehensive work of reason that takes representation as its nature—that is, representation without referent. It implies commitment to an explication of reason, since a goal requires an intentional stance. The horizon for this work is not perspectival, in the sense that the goal of reason is not to conduct a metaphysics of itself, as a means to understand its own processes. Rather, it is to respond to representations as a means to prescribe an act of reason.[14] Under this modality, the artwork is a contraction, a model of the world as it ought to be that is forged through its forcing of a wider rational project upon itself. This is an emancipatory project, not just for art but for other disciplines, that is borne out of a commitment to reason for itself; a realism that takes the world in all its complexity.[15] The commitment to this 'ought' is derived from the project of reason for itself which generates its telos through the production and dissemination of a space of reasons. This grows

13. This notion of art dismantles the requirement that art should appeal to a moral notion of empirical truth telling in the realm of 'truth telling'. Indeed, this marks a strong distinction between truth telling in modes of exposé art, where the artworks reveals and points to 'facts' in the world, art going beyond the limits of science, art as truth telling... such as art as journalism or research in forms conducive to the social sciences, images of war, images of wrongdoing in the world, and so on. Here the content of the works is made up of moral dimensions of empirical information that offer no opportunity for any discursive space for art, since they act as a form of blackmail for the viewer: any disagreement is foreclosed since opposing the truth-content of the images is made equal to an attack on the normative good of humanitarianism. This can be opposed to a notion of art as truth proposition, where the artwork must incorporate the conditions of its own construction through its operation, and at the same time extend its claim to situate itself as a truth in the world. Although this latter amoral art does not construct its authority by correlating it with moral registers of empirical truths, it claims its authority in authoring another view of the world within its means.

14. I draw this observation from John Russell Robert's commentary on representation in *Metaphysics for the Mob: The Philosophy of George Berkeley* (Oxford: Oxford University Press, 2007), where he uses Daniel Dennett to articulate the difference between descriptive and prescriptive operations.

15. I distinguish this mode of realism from various historical and traditional forms of realism in art. This includes Modernist realism that favours an empiricist approach to depiction and the understanding in works such as Seurat's Pointillism; Social Realism in works such as Courbet's depiction of social reality; Capitalist Realism, in works more familiar with Pop and Neo- Geo that were supported by the deconstructive and also postmodern claim that, since capital provides no exteriority, it is only possible to think from within its dominion. Problematically, this citation of capital collapsed what could have been productive distinctions between capital as ideological ground and capital as fate, to result in a form of tragic self-conscious anti-realism. Therefore, the realism that I am describing here is one indebted to scientific method, and which warrants a deeper excavation into its aesthetic and methodological character.

and insinuates a future by dint of realizing itself in the world as *real model*, a revolution of its own consciousness at the level of an ontology of art, but also as a general intelligence in the world that initiates an egalitarian ontology in a community of reasons.[16]

An expansion of consciousness is a project of knowledge that begins from a surpassing of narrations of alienation inherited from fixations on indeterminacy. Determinations of the possibilities of the rational imagination are cast without identifying the world of cause as prohibitive to that, nor vice versa. These norms are the basis for a bet that a correct and critical ontology will develop a form of picturing method by art that is revolutionary, a revolutionary project that exceeds the over-determination of our self-understanding as a mysterious and infinite fuel for the engines of culture, and that can enable a shared space of cognition that thinks against the abstract potential of 'a life to come that will never be known', instead demanding a community that must begin this project *now*. Those who would argue that art would be naive to participate in this project—with arguments from the side of the commodity, or that speak to art's inculcation in the markets of neoliberal capitalism—are not only wrong, they are more deeply conservative than they realise.

This version of noir, then, surpasses the conservative figure of action(ism) as coincidence between subject and law, or concept and language; one which, as we have seen, persists with a relentless violence in the world. It also surpasses the claustrophobia of our traditional noir where darkness operates as a form of matter in-itself, pressing heavily upon its agents, and where the principles that organize life enable action, but only as a commitment to desires in the present *because the future is no longer possible*. In their different ways, both of these genres, spanning vitalism and anti-vitalism, are committed to a theory of fate. Instead, the noir-determinism we have discussed recalls the filmic freeze-frame set within a 4-D model of action and representation. Another kind of metaphysics where we screw the world up into a ball and we are still on the inside. This is a form of chiaroscuro—that is, a dialectical administration working across determinism and prediction, cause and reason, sense and concept. Our detective could be another kind of Lucy, coming from somewhere and thinking from no-where,

16. My thanks to James Wiltgen for his commentary on the problem of the emancipatory dynamic of reason here.

and now released from her conventional fate; a kind of detective that navigates the conventions of the world, thinking from another place, executed in place.

Robin Mackay

Image Invasion

What I'll present here is a personal memoir with a very direct relation to the Cold War and its images, both those drawn from dystopian fictions and those stemming from efforts on the part of both the UK government and its critics in the late 1970s and early 1980s to prepare the public for nuclear Armageddon.

The benign propaganda fed to me as a child in the early 80s by my anti-nuclear-campaigning parents was a perfect introduction to nihilism. I'm not sure of the intended effect of encouraging a child otherwise diligently shielded from violent images (especially the then newly-imported American TV shows) to watch films such as *Threads*, *The Day After*, and *When the Wind Blows*—visions of pre-nuclear terror and post-nuclear devastation which supplemented the ominous warnings of the Xeroxed pamphlets often scattered about the house, both anti-nuclear campaign tracts and helpful state advisories on the appropriate action to be taken in the event of a nuclear attack. Its *actual* effect was to focus my imagination on those precious minutes after the warning was sounded,

Now the Inner Refuge

Still greater protection is necessary in the fall-out room, particularly for the first two days and nights after an attack, when the radiation dangers could be critical. To provide this you should build an inner refuge. This too should be thick-lined with dense materials to resist the radiation, and should be built away from the outside walls.

Here are some ideas:

1. Make a 'lean-to' with sloping doors taken from rooms above or strong boards rested against an inner wall. Prevent them from slipping by fixing a length of wood along the floor. Build further protection of bags or boxes of earth or sand – or books, or even clothing – on the slope of your refuge, and anchor these also against slipping. Partly close the two open ends with boxes of earth or sand, or heavy furniture.

2. Use tables if they are large enough to provide you all with shelter. Surround them and cover them with heavy furniture filled with sand, earth, books or clothing.

3. Use the cupboard under the stairs if it is in your fall-out room. Put bags of earth or sand on the stairs and along the wall of the cupboard. If the stairs are on an outside wall, strengthen the wall outside in the same way to a height of six feet.

'Now the Inner Refuge'... pages from *Protect and Survive* pamphlet, UK government, 1980.

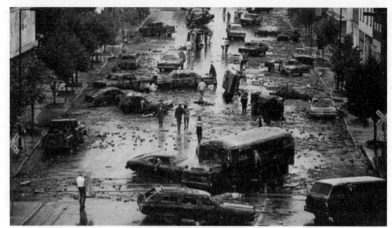

Threads (BBC, 1984)

an ultimate holiday during which all rule and law would be null and void, the conventions and strictures of society would crumble, nothing would matter any more, and everything would be permitted: schoolmates who taunted me every day could be dispatched with the sharpest kitchen knife, the sweet shop could be raided with impunity, we could set huge fires to burn down school and home alike...and so much more, as quickly as possible, while the siren wailed, in those precious minutes before the bomb dropped.

The absoluteness of the threat relativized everything; and when environmental crisis began to loom in the 90s, with increasingly cataclysmic scenarios mooted, I suspect I was not the only 70s baby for whom the sentiments of doom and visions of a devastated planet were familiar and comfortingly bleak.

The Cold War, that nebulous awareness of the great power poised for attack elsewhere, unknown and alien, and its threatened punctual incursion into reality—the Bomb—heralded transcendent objects. Yet these gargantuan abstractions immanently infused everyday life with dread...and surreptitious nihilistic thrills. And they did so through cultural forms that triggered, fast-forwarded, and dramatized the latent threat into transformed images of the everyday world—X-rays penetrating the surface of normality to set aglow the skeletal lineaments of its immanent, and imminent, ruin. The more compellingly the virtuality was imaged, the more its psychic effects had already taken hold.

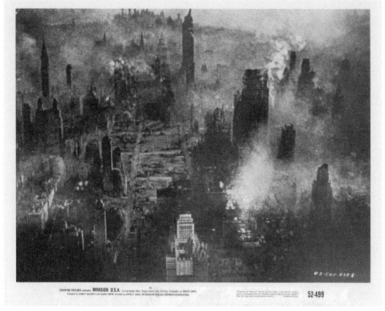

Publicity still (a devastated New York) for *Invasion USA* (American Pictures Corp., 1952).

This miscarried domestic propaganda perpetrated on me by my leftist anti-American parents mirrored earlier efforts 'on the other side', as it were, to mobilise Americans against the communist threat.

The Alfred E. Green movie *Invasion USA* (1952), with its promise to 'scare the pants off you', on one level serves as a straightforward piece of ideological programming—revealing the horror of a full-scale invasion (by an unnamed but obviously Soviet army) so as to remind the American populace of their responsibilities as citizens. At the same time it is a piece of entertainment in which we get to thrill to the spectacle of destruction and chaos. Let's take a look at some of the overwhelmingly visual promises the trailer makes to its audience:

> *An electrifying look into the enemy's plan of conquest!*
> *See New York Disappear!*
> *See Seattle Blasted!*
> *See San Francisco in flames!*
> *See paratroops take over the capital!*

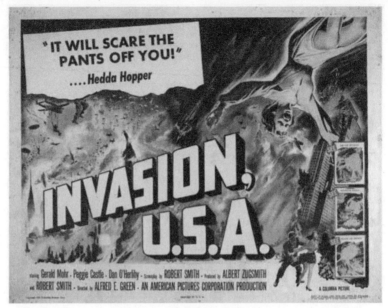

Poster for *Invasion USA*, 1952.

In addition to these promises of spectacular satisfaction, though, *Invasion USA* exhibits a reflexive awareness of cinema's ideological functioning as a form of collective dream or hypnosis, and as *inception*.

A cross-section of American society meet in a New York bar, all full of gripes and grumbles about their lives, and more interested in the next beer than in the vagaries of international politics. They pay lip service to the good fight against the evils of communism, but for them the threat is far away, and they don't appreciate its being used as an alibi by the government to make additional demands on them: price controls, commandeering of factories for military production, high taxes—each of them has a complaint.

A mysterious customer who has been listening in on their conversation, Mr Ohman (he is lugubrious, he has a strange accent, and, worst of all, he is reading a book; he describes himself gnomically as a 'forecaster') berates them for wanting it both ways: they want to be defended from the communist threat, but they also want to retain their easy lifestyles and to maximize their individual liberty and freedom from government predations; they expect the protection of the nation, but they are unwilling to go out of their way to help the state.

Dan O'Herlihy as the mysterious Mr. Ohman.

Ohman goes on to issue a sardonic warning to them about their complacency:

> *Mr. Ohman*: Yes, I'm against [war]. I think America wants new leadership [...]
> I suggest a wizard, like Merlin, who could kill his enemies by wishing them dead.
> That's the way we'd like to beat communism now. The manufacturer wants
> more war orders, and lower taxes. Labor wants more consumable products, and
> a 30-hour week. The college boy wants a stronger army, and a deferment for
> himself. The businessman wants a stronger Air Force, and a new Cadillac. The
> housewife wants security, and a new dishwasher. Everyone wants a stronger
> America, and we all want the same man to pay for it. George. Let George do it.
> *Tractor Manufacturer*: I disagree with you—I don't want to let George do it!
> *Mr. Ohman*: Then you must be the exception?
> *Tractor Manufacturer*: No—I'm George!
> *Mr. Ohman*: A very good joke, but a war is not won with jokes. To win a war, a
> nation must *concentrate*.

Distracting the assembled audience from Ohman's cryptic hectoring, the TV
news now begins to report the breaching of US borders by an unknown air force.
As the scale of the invasion rapidly escalates and US power bases are destroyed

As Carla Sanford (Peggie Castle) plummets to her doom, the nightmare scenario is revealed to be the product of Ohman's collective hypnosis.

one by one, transfixed by increasingly horrendous dispatches, the bar-room acquaintances are galvanized into action; they separate and return to their respective lives finally determined to do their bit for the now all-too-real struggle against the red terror—but one by one their efforts founder: it is too late.

The culmination of the action comes when the dame of the piece, assaulted by one of the boorish, drunken foreign troopers who have now entered the city, jumps from a high window to her death.... But in a final revelation, the whole catastrophic scenario is revealed to have been a collective hallucination, its accelerated collage of violent images receding back into the cognac glass that Mr. Ohman had been hypnotically swirling before them. Now he is gone, and they stand shell-shocked at the visions they have shared.

And truly, the trance has been an awakening—the hypnotism of the image conjured onto the TV screen by Ohman's sorcery had been necessary in order for them to appreciate that the apparently distant threat of communism was in fact already effectively in their midst, that the war was already here.

The movie ends with the cast springing into action, determined to avoid the fictional scenario they have witnessed, to do all they can for the quotidian fight for freedom before the nightmare becomes reality—ironically, they finally realise

Footage of 'enemy' paratroops, in *Invasion USA*.

that, in order to stave off communism, they must to put aside their individual interests and align themselves with state imperatives.

Invasion USA is thus a movie that thematises its own ideological function, using the small screen of the TV as a diegetic deputy for its own enterprise of image-hypnosis. But what is additionally interesting here is that all of its unprecedentedly graphic violent images of the enemy war machine in action, the entirety of the dramatic destruction of the US, was pasted together from real footage of US forces in action: that is, in order to bring the latent peril spectacularly to life, the filmmakers drew on the media made available to them by the state. At one point, when this thrifty technique threatens to become overly conspicuous to the audience, the screenwriter even introduces the conceit that the invading army, now closing in on the White House and the Pentagon, have clothed themselves in American uniforms as a deceptive tactical measure—a plan that, in one of the most memorable scenes of the movie, is thwarted by an attentive American guard as one of the invading troops attempts to pass undetected:

— *Halt, who goes there?*
— *Company B, von hundred eighty-sird Infantry.*

— *183rd, that's an Illinois outfit, ain't it?*

— *Yezz.... Yezz, Zhicago Illinois.*

— *D'you ever go see the Cubs play?*

— *Cubs...* [confused] ... *a cub iz a young enimal, a bear.*

[Blast-out ensues]

The dissimulation, of course, is in fact in the other direction: it is the reality of the violence of the US war machine that is got up in Soviet drag in order to dramatize, in heated images, the unknowable and imageless coldness of the alien threat.

Immanent Cold War dread feeds, and feeds on, its virtual cinematic culmination, its simulated irruption into reality through the image: the transcendent unknown is projected into speculative scenarios by cobbling together resources drawn from the domestic imaginary, the relation to the outside assembled from the image-banks available on the inside.

*

Today, the inhuman machine that looms over us, in certain respects taking up the vacated place of Cold War menace, produces its own cinema—or rather, various forms of *machinema*: from drone footage to awe-inspiring data visualisations to cognitively intractable image overload (even the tumblr sublime can provoke dread). Whether it concerns distant threats or intimate psychic pathologies, the sense of immanent threat here is both more diffuse and more ubiquitous: What to do with these images, which are not just seductive calls to the imaginary but also signs, icons, signals, false news, memes, machinic triggers, the asignifiant semiotic arsenal of an immanentized war? And what are they doing with us? Not images of apocalypse but an image-apocalypse.

Often these images are re-presented pointedly to us in contemporary art in order that they might be deliberately contemplated rather than passively processed. In this register, which attempts at once to strip them of their machinic function and to concentrate our minds on it, they are rendered hypnotic in a new way; ripped out of the Google search gallery and cooled by the ice-white of real gallery walls, they become images once again, and are rendered newly

unfamiliar—perhaps in the hope that spending slow time in their company will galvanize us against the immanent threat, shake us out of our zapping complacency. Even when, instead, artworks instead attempt to plug directly into the accelerated circuits of the contemporary image-world, decanting an indigestible torrent of imagery into the gallery, the intention is still, invariably, in framing them in this unfamiliar context, to *cool it*. The aim is to frame and evaluate the threat, whether by forcing the images back into an indexical mode in order to counteract the uncontrollable sliding of unmoored images flush to the neural substrate (this is still an image *of something that matters*) or by presenting their unmanageable multiplicity as such (*something that matters* is happening with the image). Indeed, many artists, whether in person or in their works or both, if not elevating themselves to the level of a saviour Merlin, affect the prognosticatory tone of a Mr. Ohman, glancing up lugubriously from his cognac and his weighty reading matter to offer his services: *it is already happening, everywhere, to all of you...but you will need me to show you—I will use the trickery, the hypnosis of images to help you see the truth...*. But this time, rather than whipping up an ersatz spectacle of destruction, what we supposedly *need* is for images to be arrested in order for their meaning to be patiently assessed and extracted. *To win the war against images, with images, a nation must concentrate.*

What image of knowledge and of the object of knowledge does this imply? Images are always specific, and for *an* image (even one that is already a multiplicity) to stand for a transcendent unknown diffused immanently into generalized dread requires the complicity of the viewer. You are only seeing one piece of the puzzle, extracted from its functional role in a neuro-machinic network; its mode of presentation solicits you to conjure up the sublime horror of the whole; but you have to *agree* to be edified in this way—and indeed, despite its air of discursive overcomplication, to enter into the context of contemporary art is largely to submit to this simple synechdochic mesmeric protocol.

Today the stock footage continually churned out by the machine itself—of which we ourselves are effectively servomotors—is too easily passed off, from inside the gallery, as the image of an alien invasion, and thrilled at (with due gravitas) as such; but it doesn't seem like we have come so far from the clunky conceits of *Invasion USA*; which is all the more problematic given that the machine that threatens us today is not just contingently, but intrinsically

unimageable, making such a mode of indirect and collusive representation increasingly obsolete.

This is how art proposes itself as the practice of making images that image the yet-to-be-known, the knowledge-bomb that has not yet exploded but whose immanent latency must be crystallised into a galvanising proposition.

Ohman's hot images reveal the *truth* of the all too easily ignored latent threat—the alien monster—by rendering it through found images as a violent fiction of assault. Today the cooling of images seeks to reveal the *truth* of the all too easily ignored Cold World that lies behind the apparent (social, sexual, informational, futural, memetic) hotness of the image apocalypse: that unknown agent that coldly manipulates the fevered participatory creation of a constantly evolving image culture, delegating its operations to the steely prowl of algorithms and the calculative capture of attention—an equally alien, equally cold creature. But ultimately this is about encountering *ourselves* as machine parts, as programmable neurobots as passively obedient to the black box of the digital media machine as the communist populace depicted in Cold War cautionary tales are to the commandments of their red masters.

In *Invasion USA* the hot shock of violent hypnotic images leverages citizens out of their own complacency about, and complicity in, an individualism that has gone too far—calling citizens to *subordinate themselves to the state in order to hold communism at bay*. In the cooling of machinematic or algorithmically distributed images in contemporary art, a dual purpose is served: art at once wants to reinstate the referential power of the image and its delivery of meaning: disconnected from its cybernetic circuits, this is, after all, an image *of something*, and in the context of art its indexical relation can be recemented; but at the same time, it wants this to constitute a revelation of our everyday alienation and complacency: to mesmerise us so as to offer us another chance once we walk out of the gallery door; to persuade us, *before it's too late*, that the immanent apocalypse today is an extinction of the human and of the human ability to engage *properly* or *meaningfully* with images. Not an extinction in the heat of the nuclear blast or in the slow death of radiation sickness, but an extinction from within, as human and social interaction itself is decanted into a system of control and circulation that machines individuality and alienates the subject. If this threat is something like a transcendent (non-)object, though, it is one that is already inside: we are face to

face with what Kant called the transcendental subject: the thing that thinks for me but to which 'I' have no experiential access, a thing which today is formatted by and plugged into cybernetic systems of control.

One might therefore wonder about this effort to use hypnosis to bring us back to ourselves, to awaken us from our complacency in order that we might take up civil arms against the immanent threat: for rather than unveiling the *real* of the image, as it claims, it simply presents us with a hypnotic collage that offers the *thrill of the real*, itself a media artefact and a form of benign manipulation, innocently unselfconscious about its own ideological and indeed economic function, and liable to fail or misfire in its ethical mission to use a privileged mode of vision to save the children of the Cold World from the image enemy.

An electrifying look into the enemy's plan of conquest!
See subjectivity disappear!
See agency and identity blasted!
See liberalism in flames!
See algorithms take over the capital!

Christine Wertheim

The New Hot in the (Old) Cold World: Adolescent Angst and the Contemporary Scene

The Cold World

The protagonist's role in dystopian fiction is often seen as a heroic one: after falling in love with a rebel—erotic love being banned in Dystopia—the central character engages in apparently insurrectionary activity. This is bound to fail, for by definition dystopias are places where it is already 'too late' to act, worlds where 'there is no longer a possibility of resistance'.[1] The affective frame of dystopian fiction is thus not the future but the present; its aim being not to propose that heroic action can influence as yet unrealized scenarios, but to shock us with 'the horror of what might follow if action is not taken *now*'.[2] Though such stories assume that social worlds can become so congealed that they can prohibit real change, is this actually the case? Does reality work that way? In 'Offred's Complicity and the Dystopian Tradition in Margaret Atwood's *The Handmaid's Tale*', Allan Weiss reviews an array of approaches to this problem in dystopian literature. It is also at the core of Dominic Fox's *Cold World: The Aesthetics of Dejection and the Politics of Militant Dysphoria*.[3] On the surface Fox's book presents itself as an exploration of the nihilisms inherent in adolescent protest. For Fox, these can take two forms, artistic or political: '*artistic* when the world made strange by our own detachment and dissociation presents itself as an object of fascination',[4] *political* when the difficulty of living reveals itself not

1. A. Weiss, 'Offred's Complicity and the Dystopian Tradition in Margaret Atwood's *The Handmaid's Tale*', *Studies in Canadian Literature/Études en littérature canadienne* 34:1 (2009), <https://journals.lib.unb.ca/index.php/scl/article/view/12383/13254>.
2. Ibid.
3. D. Fox, *Cold World: The Aesthetics of Dejection and the Politics of Militant Dysphoria* (London: Zero Books, 2009).
4. Fox, *Cold World*, 1.

as an affect of our personal dilemmas, but as the result of impersonal external circumstances. Most of his text deals with the aesthetic modes of such protest, through the lens of romantic poetry and Swedish black metal music. Only the last chapter tackles the political mode, as embodied in the figure of RAF activist Ulrike Meinhof. However, the ultimate point of the book is not nihilism, but hope, for Fox argues in his final pages that, because absolute contingency is real, fatalisms built on the sense of an unchanging and unchangeable stuckness are delusions. For Fox, then, the very idea of an unalterably 'Cold World' is itself a species of false belief.

To my mind adolescent angst is an odd place to begin an argument for the existence of real contingency. And indeed, Fox does not argue the case; he merely asserts it. On the other hand, much of what he says along the way about the adolescent mindset is noteworthy, and can act as a fruitful introduction to another way of considering the issues at stake here. Thus, whilst disagreeing with Fox that a failure to recognize real contingency is the cause of (adolescent) nihilism. I concur with his view that the encounter with contingency in adolescence is a significant political problem to which we must attend if we are to collectively move forward as a society. Before shifting to another mode of analysis, I will present a brief outline of Fox's views.

The Adolescent

Firstly, it should be remembered that adolescence is a state of mind, rather than a stage in developmental biology like puberty, and that it can occur at any time in life, and extend for decades. But whenever it comes and however long it lasts, the fundamental mental qualities of Fox's Cold World adolescents are a sense of betrayal, the lack of a common measure connecting the subject to its world, and an overriding desire to exit the cordial homeostasis of quotidian sociality. Above all, the adolescent's world is divided into two contradictory axiom sets: those of *life* and 'those of (a) *truth*'.[5] For the adolescent, the axioms of life are those imposed by the adult social order. These are

> that life is *unfair:* that existence is a struggle [...]; that there are winners and
> losers; that the prizes [...] are status and material wealth, and the forfeits

5. Ibid., 44.

deprivation and bitter humiliation [...] that life *goes on* [because] there is an everlasting continuity between life as it is now and [...] life as it has always been; that life will at best ignore and at worst completely obliterate any attempt to live otherwise than in the self-interested service of a limited set of goods [...] [and that this 'life'] 'goes on' because it is essentially homeostatic, a self-sustaining and self-correcting order [...] [that] is not building inexorably towards a moment of ultimate crisis when its contradictions will shake it to pieces.[6]

This being the case, what is nihilistic is not the adolescent, but the Cold World of (social) life itself, which is 'without any end or purpose save its own continuation'.[7] In contrast, however, adolescents hunger for the warmth of (a) *truth* that would give meaning and purpose beyond the mere continuation of what already is, some point that will make a *difference*. They are thus locked in a battle with all the appearance of a cosmic struggle. While common sense might see this as mere narcissism, adolescents themselves cannot quell their need for (a) *truth*. The struggle is intensified when the verdict seems already to have been decided: that 'life itself is all there is [...] [that] there is no place at all in the "real" world for truth'.[8] In spite of knowing this, and hence suspecting the futility of their struggle, Fox argues, adolescents insist on reopening the question of (a) *truth*.

However, in Fox's view, it is not the adult world that has decided that the life-truth war favours homeostatic life. The deciders are the adolescents themselves, even if they rebel against that decision. This is their delusion. It is also why they must become either 'militants in prototype', or nihilists: their belief in the (social) world's stuckness leaves them no other choice. On the other hand, adolescent nihilism is different from the adult social variety. As Fox argues, to truly value something 'is to value it "more than life itself", more than that which blindly survives'.[9] Believing only in the ongoingness of already-existent life, (adult) society cannot truly believe in anything, cannot embrace (a) *truth*. This, for Fox, *is* the Cold World scenario of adolescent delusion. But if life and (a) *truth* are mutually exclusive, adolescents have no choice but to turn inwards, exit society, and wage war on themselves—hence their ubiquitous turn to symbols of death,

6. Ibid., 44–5.
7. Ibid., 45.
8. Ibid., 44.
9. Ibid., 45.

and the essentially aesthetic nature of their revolts. As history attests, this stance usually ends in fashion. What was once defiance quickly becomes orthodox, a performance of refusal and not a real act. The only way out is to transition to actual insurrection, and become an activist; one who not only pronounces on what displeases her, but also makes sure that what does so occurs no more. And this radical is a *she*, for, although most Foxian aestheticians of dejection are male poets such as Coleridge, Hopkins, and Malory, dark metal popsters such as Malefic and Xasthur, or his beloved Codeine, whose blood-freezing anti-charm, Fox argues, is a riposte to the 'too many notes' of contemporary accelerationism, his lone example of a *political* deject is the dysphoric militant Ulrike Meinhof, a young woman. Yet it is *she* who most fails to grasp the fact of real contingency and the hope it can bring.

The Militant

'We do not presume to know the mind of Ulrike Meinhof, and what follows is not to be a séance'.[10] Thus Fox begins his final chapter, 'The Brain of Ulrike Meinhof'. Though no footnotes contextualize this quip, it clearly references Chris Kraus's piece on Meinhof, 'Aliens and Anorexia', written decades earlier.[11] Here Kraus tries to make sense of the seemingly inexplicable fact that a well-brought up bourgeois young woman with a good job and much public esteem could cross the line from critic to armed activist, by literally trying to get inside her subject's mind. Fox too treats Meinhof's transition as a mystery: 'Nobody of sound mind could consider such an aberrant course of action', he declares authoritatively.[12] But Fox does not believe that processes of identification are appropriate methodologies for understanding one's subject—at least not when this subject is a woman, even though his own chapters on boy-geniuses smack of delighted identification to me. (Why is it that boys are allowed the pleasure of identification with their own traditions when being critical, but if women do the same they are regarded as nostalgic, narcissistic, or just plain gaga?) Fox's first explanation for the enigma of Ulrike is the fact that, before turning militant, she had had a tumour removed from her brain. As 'everyone knows', he states, 'the

10. Ibid., 57.
11. C. Kraus, 'Aliens and Anorexia', in C. Kraus and S. Lotringer (eds), *Hatred of Capitalism* (Los Angeles: Semiotext(e), 2002), 57–62.
12. Fox, *Cold World*, 58.

ultimate causes of unsoundness of mind are to be found [...] in the neurological substrate of consciousness'.[13] Clearly this is not a genuine argument but a dig at Kraus, to whose methods and conclusions I will return.

The rest of Fox's chapter deals with the question, pulled from Meinhof's own writings, 'of whether or not the raid to get Andreas Baader out of police custody [the act in which she 'crossed over'] would have been undertaken if it had been known that Linke, an elderly librarian, would be shot and injured in the process'.[14] To summarize Fox's response to this question, and his judgment of Meinhof, the inability of the RAF, and of Meinhof in particular, to predict that a civilian might be present at the scene of Baader's escape, represents 'a gap in symbolization'.[15] This gap, which the public will invariably construe as a failing of moral awareness, persists 'even when the claims of [...] morality are suspended',[16] as is the case with armed revolutionaries. This is where the concept of contingency enters, for, according to Fox, neither bourgeois moralists nor militants are capable of symbolizing contingency. The bourgeois public cannot conceptualize the contingencies that occur in states of existence where hazard and insecurity play an intrinsic part, while revolutionaries are so fixated on struggle that they can't conceive of civilians in any terms other than as 'things' that get in the way; matter out of place, to use Mary Douglas's felicitous phrase. Fox thus concludes that Meinhof failed as an armed revolutionary just as she failed as the bourgeois intellectual she tried not to be. With respect to the phenomenon of real contingency, for Fox, the radical Ulrike suffered the same conceptual blindness as her stuffy predecessor.

This is the general lesson we learn from the misconceptions of dysphoric militants and revolting adolescents: that the Cold World is a myth, for radical contingency will ultimately force even the deadest materials, including social fabrics, to change. (Similarly, the philosopher Peirce famously described matter as 'processes frozen by habit'.) Once we realize this, according to Fox, the icy stuckness begins to dissolve, as new phenomena become visible: 'the "inorganic life" of anonymous processes; the archipelago of local truths woven out

13. Ibid.
14. Ibid., 61.
15. Ibid.
16. Ibid.

of amorous encounters; the secret enjoyment of others which is never fully apparent [...] in any event [the] touch [of] the real'.[17]

The harshness of totalitarianism, whether seeming or real, and the nihilistic fatalisms this produces, can all be overcome by the simple recognition of blind chance! This is an odd argument, for while truly random events may well occur—even in their most radical forms, such as the Peircean hypothesis that the laws of nature are subject to change—nothing guarantees the time-frame of such events. They may happen at any moment—next minute, next week, or a hundred trillion years from now, and NOTHING may happen in between, leaving everything *exactly* as before for that entire era. More importantly, the mere recognition of contingency is no solution to adolescent angst. The (social) world may not be frozen solid but, as Fox suggests in setting out his own argument, it nevertheless presents a problem for adolescents who, contingencies or not, rightly perceive a contradiction between the axioms of social life and those of (a) *truth*. And whilst this question of (a) *truth* may be linked to (a) contingency, it is certainly not that of 'inorganic life'. Before turning to other ways of conceptualizing the stakes here, I will finish with a few words on Kraus's view of Meinhof.

For Kraus, Meinhof was not a failure, but a roaring success. However, Kraus has a radically different view of the militant's aim. For this (female) writer, the activist's goal, *this very particular* activist, was not the physical death of the state, but its symbolic annihilation; confronting it with something so in excess of its symbolic capacities that its powers of representation would fail altogether. In Kraus's view, for Meinhof, the most unsymbolizable phenomenon she herself had encountered was the group of delinquent girls she met at a reform school whilst writing a play prior to joining the RAF. If, as Fox shows, the behaviour of delinquent boys is often valorised as aesthetically interesting, one of the most overlooked groups in our society is anti-social girls. Indeed 'anti-social girl' is an oxymoron. But in Meinhof's unfinished script, published years after her death, some of these girls, rather than rail against the machine, embrace their invisibility and willingly step into the 'angelic' space of the unspeakable to which they have been so casually assigned. This, according to Kraus, is what Meinhof craved, and what she finally achieved in death. *This*, the unspeakability[18] of her chosen

17. Ibid., 70.
18. As will be seen in the next section, this 'unspeakability' only applies to forms of articulation reliant on public discursive language. In fact, this position can be put into words, but of a radically different kind.



symbolic position, is what keeps Meinhof alive in the political imagination, not her failure to recognize the flesh of her fellow civilians.[19]

Precisely this embrace of the gap in symbolization is what is at stake for all adolescents. It is also the subject of the collective work of Willy Apollon, Danielle Bergeron, and Lucy Cantin, three Québecois psychoanalysts who work with highly disturbed teens. Based on the conclusions this team draw from their practical work, I argue in the last section of this paper that adolescent nihilism (whatever the chronological age of its adherents) is a logical consequence neither of a 'Cold World' nor of a failure to acknowledge contingency, but of the very structures of the psyche itself, and its attempts to deal with that which cannot be symbolized in quotidian social life, and yet must be verbalized somehow.

The Adolescent After Lacan

Willy Apollon, a Haitian philosopher and psychoanalyst, along with Danielle Bergeron and Lucy Cantin, collectively lead the *Group interdisciplinaire freud-ienne de recherche et d'interventions cliniques et culturelles* (Gifric).[20] Gifric is an umbrella psychoanalytic organization housing various entities, including '388', a clinical facility specializing in treatments for highly disturbed adolescents. In analytic terminology, its clients are psychotic. In this paper, we need not occupy ourselves with the difference in clinical structure between neurotics, who compose most of civil society, and psychotics, who are less common, though apparently growing in number. The point here is the developmental phase known as adolescence in which the distinction between these two begins to manifest behaviourally. By focusing on psychotics rather than neurotics, the clinicians of Gifric and the workers at 388 shed light on the importance of contingency, and the defects of symbolization, in adolescent psychic development.

In summary, the argument is as follows: in each and every human being there insists some 'want', some node of (un)pleasure—what the French call *jouissance*—that cannot be put into words. At least it cannot be put into the words of ordinary discursive language—the language of the social link—precisely

19. Likewise, when men assume the place of unsymbolizable social 'dirt', aka the criminals known as Christ, Chopper, and Bronson, they also command respect, but not the female of the species. A fantastic example of this is the film *A Question of Silence* (1982, dir. Marleen Gorris), which, although it features grown women rather than adolescent girls, makes the same point.
20. <http://www.gifric.com/Index-en.htm>.

CHRISTINE WERTHEIM / THE NEW HOT IN THE (OLD) COLD WORLD

because it is absolutely unique and particular, whereas communicative social speech and writing must by definition rely on degrees of generality. (*Jouissance* can in point of fact be articulated verbally, but only by another kind of language we might wish to call 'constructivist', for the enunciation of *jouissance* is a creative construction brought into being by a subject's constitutive re-cognition of its own absolutely particular desire/s, not a re-presentation referring to some a priori [objective] phenomenon. The problem of distinguishing between these two utterly different linguistic modes requires a more sophisticated semiotic vocabulary than is currently in circulation.) Furthermore, this *jouissance,* this sense of a particular and non-communal wanting, has the feeling of being so unlike what any-one could possibly of their own volition desire, that it seems as if an alien *It* is inhabiting the place where (the) I ought to be. In other words, this wantingfulness feels like something absolutely foreign to (a) being, and yet it is, as Lacan says, the most 'extimate' part of one's self. This is the (hypo)-thesis of the form of human-alien-ation called by the name of Unconscious, as proposed by Freud and continued by his Lacanian followers, including those who, like the members of Gifric, describe themselves as 'after Lacan'.[21] It should be kept firmly in mind that in this hypothesis the alienating effect of unconscious desire is not caused by external conditions, capitalist or otherwise, and hence cannot be overcome by external fixes. It is a structural fact of the psyche itself (at least that is the proposition).

In light of the above, from the analytic perspective, all human beings must deal with two phenomena other animals need not face–the fact that our primary communication system, language, is limited, for it cannot name our most in/extimate desires; and the fact that, in tandem with this, if not as its direct effect, we are flooded with the un/pleasures of an alien-ating *jouissance* that posits itself where (the) I would be. Though both phenomena are encountered by tiny babes, the gift of communal social language holds them at bay until the developmental phase known as adolescence—at whatever age this finally sets in—when the tidal wave of each subject's own desires, and its parents' inability to give these a name, bring them flooding back.[22]

21. See W. Apollon, D. Bergeron, and L. Cantin, *After Lacan: Clinical Practice and the Subject of the Unconscious* (New York: SUNY Press,. 2002).

22. To speak of a subject's desire as if the subject were an agent separate from its actions is a fallacy. The analytic 'subject' is nothing but its desire. This is why the 'I' only comes into being as a self-construction when it re-cognizes itself where the alienating and foreign It-want once was.

According to Apollon and other members of Gifric, if teenagers are moody and rebellious, this is only because they understand that the adult world cannot assist them. And so they cluster together, looking for support from each other in their attempts to invent new resources to cope with that part of themselves which cannot be re-presented by the existing social order. However, this defect of social discourse is not a contingency we could overcome if only we knew more. It is structural, precisely because each adolescent's desire is absolutely unique and particular to itself, whilst communal language is always in some sense generic. Adolescents must thus face, by themselves, the specificity of their own desires, and their disappointment in their parents' inability to help put these into words. Inevitably, this troubling combination, and the superhuman task of (re)-construction it demands, can produce moodiness, abreaction, disobedience, and even nihilism.

From the psychoanalytic perspective, overcoming this nihilism is what shifts us from adolescence to proper adulthood. And all that this requires is that we realise our wants in a construction as unique as it is contingent; that we accept that we own this personally; and that we do so without harming others (!) This is why *subjective* construction is an ethical as well as a political task. In contemporary society, such an erection can take a lifetime, and many don't achieve it even then. Without it however, as Fox correctly argues, we are stuck forever in nihilism or conformity. Yet one thing is certain: what matters here is not simply that absolutely contingent events exist in the utterly unique and never before manifest constructions of each newly emerging subject. What matters is that we determine the exact structures of these contingencies through constructive acts of honest self-re-cognition. Though no doubt the term 'honesty' here is highly problematic, until each of us does this with ourselves, we cannot mature into proper adults; and until we do that, we cannot overcome our collective tendencies towards conformism, nihilism, dejection, and dystopia.

Brian Evenson

Dark Turns of an Imaginary Past

Maybe we can start by going very quickly through the history of how we think about writing's relationship to life. In the eighteenth century, probably the most common way to consider this relationship was to think of it as a didactic one. Fiction was something that was meant to teach us something about life—or even to teach us how to live. It was instructive and, as such, was judged by the degree to which it either succeeded or failed to instruct us. Good fiction encouraged us to be good, bad fiction either failed to teach us anything or encouraged us to be bad. That's a view that goes all the way back to just before the beginning of the common era, where we find Horace, in his *Ars Poetica*, suggesting that poetry should at once 'delight and instruct'. So, we enjoy reading something, but we learn from it: the enjoyment is there to keep us in what Samuel Johnson called 'pleasing captivity'.

Such a view puts a premium on content: books represent a life that we should want to live, and by reading them we want to become better people. But even in the eighteenth century it wasn't the only view. Critics and writers were already beginning to think differently about fiction, and to think about it less in terms of the information that was being presented and more in terms of *how* that information was presented. Henry Fielding, in *Tom Jones*, compares writing to cooking and suggests that 'the excellence of the mental entertainment consists less in the subject than in the author's skill in dressing it up'. The subject matter provides the raw material, but the final product is due to the chef's skill. What matters is not so much what is depicted, but the way it is 'cooked'.

For me, that is a question that fiction will return to again and again: Do we depict something as it is in life or do we shape it? To what extent is fiction mimetic, meant to depict life, and to what extent does it give us something different to what life can provide?

People like Johnson insist on fiction depicting the good. Or, if the bad is depicted, that it should be shown in a way that makes it clear that those who

are bad will be punished. By the time we get to the nineteenth century, some writers actively disagree. If fiction is meant to depict life, Stendhal suggests, then it should depict what's there, not give us a cleaned up and sanitized version of life. Says Stendhal, '[A] novel is a mirror carried along a high road. At one moment it reflects to your vision the azure skies, at another the mire of the puddles at your feet. And the man who carries this mirror in his pack will be accused by you of being immoral! His mirror shews the mire, and you blame the mirror! Rather blame that high road upon which the puddle lies, still more the inspector of roads who allows the water to gather and the puddle to form'.[1] In other words, why should a novelist be blamed for depicting what is there to be depicted?

That mimetic model still dominates ideas about fiction. However, even if you see fiction as a kind of mirror for life, it is worth thinking about what mirrors actually do: they throw back an image that is the reverse of what is actually present. A mirror both depicts something and reverses it. Mirrors can become foxed and tinted, and can begin to deform the image in very interesting ways. They can fog over and depict vague shapes where reality has harsher outlines. They can be broken and then reflect life as a myriad of shards. If you do accept the idea that fiction is mimetic, you also have to consider that the way in which fiction depicts life might also transform it.

I think to the question 'Do we depict something as it is in life or do we shape it?' such fiction answers 'Both: How can we depict something in words without shaping it? And since we can shape it, let us shape it as effectively as possible'.

I tend to think of the relationship of words to what they depict—and by extension that of fiction to life—as like the relationship Deleuze and Guattari suggest between the wasp and the orchid. The orchid has a particular shape that the wasp interprets as wasp-like, and this draws the wasp to it. In doing so, the wasp picks up bits of pollen and carries them away to the next wasp-like orchid it sees, thus becoming part of the orchid's reproductive system. In other words, something in the plant world takes on limited insectile qualities, which attract an insect. The insect's actions make it temporarily a part of the plant body and aids in the plant's reproduction. Deleuze and Guattari talk about the orchid forming 'a map with the wasp'[2] that ends up retaining the separate identity of each while still letting each serve as a catalyst for the other.

1. Stendhal, *The Red and the Black*, tr. G. Scott-Montcrieff (New York: W.W. Norton, 2004), 515.
2. G. Deleuze and F. Guattari, *A Thousand Plateaus*, tr. B. Massumi (Minneapolis: University of Minnesota Press, 1987), 13.

Life is something fiction can use as a catalyst to get elsewhere. Fiction is not a question of trying to depict what *really happened*, but of using some aspect of life as a catalyst, of recognizing those moments when life begins to take on the shape of the fictional wasp, of using life in ways it doesn't even suspect it is being used. In other words, using life as a provocation.

In that vein, life in general, and moments from the past in particular, become a provocation. I'm circling around nostalgia, the way we look back at the past with longing in a way that transforms it into something that it is not. Usually when we think about nostalgia we think of it as creating a kind of rosy hue around things, the past as viewed through a lens smeared with Vaseline. But there is a potential for nostalgia to serve together with a destructive and potentially dismembering impulse in such a way as to lead to effective art.

<p style="text-align:center">*</p>

When I was working on my PhD in critical theory two and a half decades ago, nostalgia was a loaded term. In one of the postmodern literature classes I took, the worst thing you could accuse a book of was being was nostalgic. The term still makes me nervous.

Perhaps the simplest and most value-free definition of nostalgia is as a 'longing for something past'. It has been complicated in our usage by the way in which a value judgement is usually associated with that longing. For instance, Merriam-Webster defines nostalgia as 'a wistful or excessively sentimental yearning for a return to or of some past period or irrecoverable condition'.

For me, there are two important things about this more specific definition. Firstly, it defines nostalgia as excessive (excessively sentimental in this case); and secondly, it postulates an *irrecoverable* condition. For us to be truly nostalgic about something, it suggests, there has to be a sense of it being in the past in such a way as to be *beyond* recovery. There's a permanent sense of loss or distance thus associated with nostalgia.

I want to mutate these definitions, to try to get away from the word 'sentiment' or 'sentimental' so that we create a concept more useful to art. If we allow ourselves that liberty, a contemporary definition of nostalgia sounds something like this:

a. Nostalgia is a longing for an irrecoverable condition or an irrecoverable past.

b. Nostalgia is excessive.

'Excessive' is more provocative than 'excessively sentimental'. Excess, as Georges Bataille suggests, is a means of apprehending and controlling the world, a sort of radical openness that rapidly opens into negativity and potential destruction. If nostalgia is an excessive action, and if that excess can't be simply dismissed as sentimental, then it opens up into other sorts of excess, and ultimately into death and nothingness.

Admittedly I'm creating a wishlist for what I wish nostalgia could become, rather than describing nostalgia as it exists. I can think of many possible objections that Bataille himself (or really any theorist) might make. But, as artists, it is not our task here to describe nostalgia as it functions, but to establish through our words a velocity that allows us to transform an idea into something that is artistically provocative. Words, for a writer or an artist, in the context of fiction and in a context such as this, are not only or even *primarily* descriptive, but are intensive and transformative. Words are something that we experience and that change us.

On the one hand the excess within nostalgia ends up transforming the irrecoverable past (or the irrecoverable nostalgic object) into a fetish object. Through nostalgia, the object develops an aura, becomes magical, becomes supercharged. Any genuine attempt to recapture the irrecoverable past in art is an attempt to capture this aura, this magic, this intensity. In writing, this might lead to lyrical descriptions of a lost past, an attempt to capture, via the manipulation of language, a certain intensity related to the past or a past event. But it can also lead to something operating at the level of sound or syntax, a quiet buzzing. Or it can lead to disruptions within the flow of the sentence, fracture and fragmentation—whatever it takes to capture that aura or intensity. Indeed, the writing, the substitution of language for reality, becomes a compensation for the loss of the object itself, and as such a *substitute* for the object. The lost past remains out of reach, but one is given a lingual substitute for it, something that captures verbally an intensive aspect of this lost past.

On the other hand, this excess simply opens up into other excesses, into destruction. The genuine attempt to recapture the irrecoverable past object in art, to the degree to which it participates honestly in this excess, does not stop with capturing the aura or the magic, for there always exists a tension between the reality of the past event and the separate object it has become, first through

the distance of memory, and then through the distance of art. Remembering something transforms it. Making an artistic rendering of it transforms it further. For anyone serious about the technical aspects of their craft and willing to submit to the impulses of the art itself, this will lead to a conflict between the demands of the nostalgic object and the demands of an artistic medium. Even if we set out to render the source of our nostalgia perfectly, we find it transformed by the way the word asserts itself on the page or the way paint goes onto the canvas or the way in which an image is flattened and framed and transformed. A piece of art is good if that transformation simultaneously captures the intensity of the nostalgic object and makes it into something entirely different with its own, unique power. By offering itself up as something that serves as a substitute for the lost object, the work of art participates in the transformation of that object, and in its destruction. So that rather than the dreamy farawayness of nostalgia and the univocal focus on the past object, the objects of concentration are now double and intermittent. On the one hand there is the irrevocably lost past object of nostalgia. On the other there is now the artistic object, which has a reality all of its own and an intensity which it might share not only with the individual subject to nostalgia but with others. Indeed, nostalgia as expressed in art is excessive in this respect as well: it makes nostalgia a communal rather than an individual experience. Nostalgia flows out of the individual as an intensity and provokes a group.

The paradox: if a work of art evokes nostalgia, it ultimately does so by using the actual past to create a past that *never* existed. To the degree that it captures a past intensity or feeling, it makes the past event unnecessary. We switch our allegiances from the past to the present artistic object, *at the expense of the past*, ultimately edging it further toward forgetfulness and destruction.

Art, then, can begin with nostalgia for something but, in embodying that, it destroys or compromises its original object while appropriating its aura or intensity. Aesthetic nostalgia, then, is intimately bound up in reconfiguring, disfiguring, dismembering, or destroying an originary event.

I want to suggest two ways to think about this, both of which I take from the oblique writings of surrealist artist Hans Bellmer. The first suggests that the collision of the past object with a medium (words, paint, etc.) creates an assemblage that is the finished art project, and which would be impossible

without either past object or the medium, but which ultimately is something different from either of them. The medium is encoded on the nostalgic object and the nostalgic object on the medium (cf. Deleuze/Guattari's wasp/flower). You might think of this in terms of the paintings of another surrealist, Di Chirico, whose paintings are interested in capturing a moment of childhood or dream, but capturing not so much the literal moment as a lingering strangeness and intensity. Even when Di Chirico's own writings suggest him to be drawing on an actual event, that event hardly filters through. What comes through is not his childhood, nor the viewer's childhood, nor, really, childhood in general, but a mood, a plateau of intensity that the viewer is invited to experience. Since this is brought about by the coding of the lost past onto the medium and vice versa, the partial absence of both in favour of the amalgam is what makes the artwork what it is.

Bellmer calls this making the image 'interanatomical'. Says Bellmer, in 'Notes on the Subject of the Ball Joint', 'it is necessary that an amalgam be formed of the objective reality that is the chair and the subjective reality that is the doll, an amalgam endowed with a superior reality since it is objective and subjective at once'.[3] So for Bellmer, the doll and the chair end up creating something else that is neither doll nor chair and yet both doll and chair. That's similar to the interaction of the wasp and the orchid, and similar also to the way in which the translation of the past into words creates something entirely new.

In addition, Bellmer believes that the body image is fluid and that different parts of the body can symbolically migrate—a theory Bellmer derives from psychiatrist Paul Ferdinand Schilder's thinking about the body image. Any part of the body can potentially stand in for any other. Bellmer talks about the way in which, if you have a toothache, you can transfer the pain from the tooth to another part of the body by, for instance, clenching your hand and digging your nails into your palm. The pain migrates from tooth to hand, as if the hand itself has become a substitute tooth. In that sense, we can see the work of art as bringing about a migration of the power of the nostalgic object. It is a migration of pain from the tooth to the hand.

In Vladimir Nabokov's *Lolita*, Lolita is not the first instance of the narrator's sense of nostalgia and loss. It began with a girl he met when he was quite

3. H. Bellmer, 'Notes on the Subject of the Ball Joint', in S. Taylor (ed.), *Hans Bellmer: The Anatomy of Anxiety* (Cambridge, MA: MIT Press, 2000), 212.

young, to whom he was intimately connected, but who vanished from his life. It is nostalgia for the lost summer spent with her that leads to his obsession with girls of a certain age, and which in turn leads to his obsession with Lolita, who at first strikes him as a reincarnation of the girl he knew so many years ago. Lolita's appeal is at first wholly nostalgic, a chance to relive a period that he thought to be forever lost. Humbert Humbert has succeeded in having the pain migrate from one tooth to another, has moved from nostalgia to a recaptured intensity that renders the original nostalgic object obsolete: a past moment that serves as a catalyst for art will end up, to the degree that the work of art is successful, rendering itself obsolete. When the narrator loses Lolita irrevocably, he descends into nostalgia again, recounting and rethinking in minute detail his time spent with her, focusing on the syllables of her name, on recreating her with and through *language*. That book opens after everything has already happened, with the narrator reducing an actual person he knew to language: 'Lolita, light of my life, fire of my loins. My sin, my soul. Lo-lee-ta: the tip of the tongue taking a trip of three steps to tap, at three, on the teeth: Lo. Lee. Ta.'[4] By being rendered in the medium of words, the nostalgia becomes an intensity. Here pain moves not from the tooth to the hand, but from the eye to the tongue.

This is to me key to how I see nostalgia functioning in regard to contemporary artistic practice. What we are nostalgic for is not an event but an intensity, an excess: by clenching our hand tight enough around the pen to transfer the pain, we want to transfer the pain from the past to the hand that constructs the work of art. And to do this we are willing to dissect, destroy, and dismember the actual past itself.

A prime example of this, particularly in relation to the Cold War, might be found in China Miéville's 2009 novel *The City & The City*.[5] The novel presents a split city, not unlike Berlin before the Wall fell. On one hand we have Beszel, a dilapidated Eastern European city, on the other we have Ul Qoma, more modern in some ways, but decidedly different. Like West and East Berlin once did, Beszel and Ul Qoma occupy the same city; but unlike Berlin, they aren't sharply divided by a wall. Instead, they overlap. The citizens of each city pass by one another, but they have trained themselves to 'unsee' the citizens of the other. There are

4. V. Nabokov, *Lolita* (New York: Vintage, 1997), 9.
5. London: Del Rey, 2009.

places in the city where the citizens directly intersect without interacting, areas referred to as 'crosshatching'. In other words, a way in which an artist might render shadow in his medium becomes a definitional field for the interaction of citizens within physical spaces. In addition, there may in fact be another, third city, invisible, existing largely in the crosshatching between the two, and which may exert more control over them than the inhabitants of either city realize.

On one level, this is simply a metaphorical reworking of a divided city in a way that at once acknowledges its connection to post-WWII Berlin and also allows for an acknowledgement that all cities are divided, certain things legible to some and not to others. On another level, as a speculative writer (and visual artist) Miéville is taking ideas and perhaps his own memories of a post-WWII Berlin and using them as fodder, chopping them up, transforming them, and offering something that is at once not at all true to the reality of that divided city yet still captures, in a unique way, its real intensity. Indeed, my most vivid memories of visiting Berlin when I was a teenager are less about the stark divisions between East and West and more about the third city existing in the crosshatching: the black marketeer who seemed able to come up with anything and who we saw, by chance or by accident, on both sides of the border. Or the colonel who took us across and who didn't have to wait at the border, whose car was not searched, not even stopped, despite it being clear, even to me, that it contained several things that it shouldn't have. And the way in which these two, so different in some ways, had so much in common in others, both being representatives of that third, invisible city which was, perhaps, the real locus of power. In reading *The City & The City* I found myself thinking intensely of those experiences, vaguely but intensively nostalgic for them, in a way that I haven't been while reading more realistic fiction actually set in Berlin.

I could argue the same sort of thing (and in very specific ways) with the fantastical spaces of Philip K. Dick, Samuel Delany, or any number of speculative writers who grew up in some sort of proximity (preferably a waning proximity) to the shadow of the Cold War: this thing that shaped us, that led us to hide under our desk, has become the pain transferred from the tooth to the hand, and the object of dark nostalgia that becomes, at its best, an occasion for art.

Reza Negarestani

Requiem for Detective Fiction

The Pledge: Requiem for the Detective Novel is a novel by the Swiss dramatist Friedrich Dürrenmatt published in 1958. It tells the story of a super-detective named Matthäi who is now insane and working at an isolated gas station in a small forsaken town. Years earlier, Matthäi had come to this place to solve the case of a child murder. From the start, Matthäi begins to assemble a highly detailed profile of the criminal. In effect, he solves the mystery right after taking the case. Having solved the puzzle, Matthäi then devises an elaborate trap to catch the suspect, to confirm his sure theory and close yet another case. But the serial killer never arrives. Shocked by the failure of his method, Matthäi succumbs to alcoholism. Years later, with Matthäi now insane, it is revealed to the new chief of police that the serial killer was indeed heading to the trap on the day Matthäi expected him, but, in a sudden twist of fate, died in a car accident on his way to bite Matthäi's bait.

This is a brief but sufficient summary of Dürrenmatt's requiem for the detective novel. We could even condense it into a simple description: This is a story about the logic of detection and its failure owing to its faith in the prior reliability of law-like generalities. Now I would like to make the unsurprising claim that *The Pledge* is a philosophical thriller about epistemic inquiry, in particular an old yet still open wound precipitated by epistemological scepticism. The nature of this wound is precisely what I would like to address here. But before that, let us briefly say that its nature is the problematizing and unresolved entanglement of deductive and inductive inferences in epistemological investigation, particularly that of science.

What turns Dürrenmatt's novel into a requiem for detective fiction is the way in which, in his story, the problem of induction implodes the logico-deductive framework of detective fiction from within. It has long been suggested that the traditional detective fiction—and the figure of the detective—represents a method of investigation that is, in essence, logical in the sense that it primarily

focuses on the deductive rules of thought. Inductive generalizations of obser-vations—patterns, evidence, etc.—are only secondary in their import. They are aspects of police work rather than the defining characteristics of a true detective. Therefore, in the classical framework, the archetype of the detective is not a scientist but a logician proficient in following deductive chains of thought no matter how convoluted they might be and regardless of how far beyond salvage the crime scene is contaminated. The triumph of the detective, the solving of the crime, owes not to the forensic expertise of the detective, the sophistication of laboratory instruments, and certainly not to the competence of the police force or its information-gathering capabilities but, first and foremost, to the logico-deductive skill of the detective, whose disinterested and mechanical nature is often whitewashed by his eccentric and ingenuity-feigning charisma.

The contemporary hard realist detective genre, on the other hand, identifies itself in complete contrast to this logical-deductivist structure of the traditional detective fiction. Examples of the hard realist detective genre would be Forensic Thrillers and Police Procedural Dramas, franchise series such as *CSI* and *Law and Order*. What distinguishes the hard realist genres from the traditional form of detective fiction is the strong emphasis on the insufficiency of the logical method of analysis. Instead they underline—often to the point of ideological valorisation—empirical methods of crime solving and the technoscientific adequacy of laboratory instruments, forensics, and police profiling. A half-burnt cigarette in an ashtray is no longer a mere hypothesis in the detective's chain of deduction whose truth can be determined by procedurally exhausting all possible contradictions and incompatibilities. It is instead a subatomic field teeming with empirical footprints, DNA traces, structural patterns that reflect the muscular and sensory-motor habits of the criminal, and chemical molecules rich with geographical metadata out of which the complete profile of the culprit, their scientific image—both biological and psychological structures—can be put together. It is in this sense that the new genre replaces the frigid logical framework of the traditional detective fiction with the cold realism of science, capable of uncovering the hard naturalized and empirical facts of physical laws behind any inconspicuous sociocultural, political, or quotidian situation.

I associated hard realist detective fiction with an ideological valorisation of the empirical sciences and the efficacy of technoscientific techniques. This is

because it is principally based on the subsumption of every psychological, sociocultural, or political construct under physical laws whose hard facts can be extracted—thanks to the allegedly unshakable epistemic adequacy of empirical methods of investigation—by contemporary technoscience. In this sense, hard realist detective fiction is fully in tandem with a liberal naturalizing program whose aim is to unveil the ice-bound universe of empirical and naturalized facts behind every potential terrestrial crime scene, be it social, political, or economic. It is this uncritical affirmation of the foolproof adequacy of empirical methods, employed within an overarching naturalizing program whose limits have been left uninvestigated and undemarcated, that makes hard realist detective fiction a shining example of neoliberal capitalism's appropriation of the sciences, rather than an exemplar of the modern empirical sciences as such. New detective fiction, accordingly, derives its legitimacy from the reliability and efficacy of technoscientific methods. But the problem is that, just because something reliably works, that does not make it essentially unshakable at its foundation, nor does it confer epistemological legitimacy upon it. The efficacy of technoscientific methods in the epistemological investigation of every possible crime scene—i.e. the claim that it always works—is exactly the blind spot of hard realist detective fiction.

My contention is that Dürrenmatt's novel underlines just this precarious blind spot. It distils the superacid of epistemological scepticism that corrodes the foundations of both the traditional and new realist detective genres. It is as much a requiem for the traditional form of detective fiction as it is a requiem for contemporary hard realist forensic fiction based on the organon of true detection, science. As mentioned above, one of the main points of this epistemological scepticism that Dürrenmatt utilizes in his novel is that every genre of detective fiction is built on an epistemological system within which we are not only dealing with logical deductive procedures (which are overemphasised in traditional detective fiction). More importantly and fundamentally, we are also dealing with inductive inferences employed to derive law-like generalities, patterns, and predictions on the basis of observations or past experiences pertaining to different occurrences, clues, and footprints. Now, to the extent that any epistemological investigation has an underlying inductive component (call it the inductive profile of the crime scene), regardless of how sound the deductive logical reasoning of the detective might be, the old and new problems

of induction can at any time encroach upon the procedures of investigation and disrupt the anticipated resolution.

It is not that Matthäi's logical inference is unsound, nor is it that his method of profiling the criminal's features, behaviours, and predatory routines is flawed. He is as gapless as a logical machine and as effective as a high-tech forensic laboratory. It is just that the problems of induction (of singling out patterns and law-like regularities, of forming predictions and confirmations) have caught up with his methods. And it is precisely the old and new problems of induction—the corrosive substance of epistemological scepticism—to which both detective fictions and scientific inquiry qua true detection are in one way or another vulnerable.

But what are the old and new problems of induction?

First let us look at a few definitions:

1. *Deduction* can be roughly understood as a form of reasoning that links premises to conclusions so that if the premises are true, following step-by-step logical rules, then the conclusion reached is also *necessarily* true.

2. *Induction* or inductive reasoning cannot be formulated as neatly as deduction. But roughly it is a form of reasoning in which premises provide strong support (whether in causal, statistical, or computational terms) for the outcome of the inference.[1] Whereas the truth of the conclusion in deductive reasoning is logically certain, the truth of the outcome in inductive reasoning is only *probable* in proportion to the supporting evidence. Hence, as evidence piles up, the degree of supporting valid statements for a hypothesis indicate that false hypotheses are—as a matter of generalization—probably false, and in the same vein, that true hypotheses are—as a matter of generalization—probably true. But this dependency on evidence also means that inductive inference is contingent and non-monotonic. Non-monotonicity means that addition of new premises can fundamentally change the truth of the conclusion, either drastically raising or lowering the degree of support already established for the inductive outcome. It is this epistemological (rather than ontological) contingency and

1. 'My reason for using the expression "outcome" rather than "conclusion" (which might seem a more appropriate way of characterizing the terminus ad quem of an argument or inference) is that although the whole point of a first order probability argument is to generate a terminal outcome, the relation between a terminal outcome and the premises of the argument is radically different from that which obtains between what we ordinarily call the conclusion of an argument and its premises.' W. Sellars, 'Induction as Vindication', in *Essays in Philosophy and its History* (Dordrecht: Reidel, 1974), 370.

radical non-monotonicity that operates in the background of Dürrenmatt's novel and eventually throws Matthäi's elaborate system of detection, and his mental health, into disarray.

Now back to the problems of induction: David Hume formulates one of the strongest forms of the old problem of induction as follows: Inductive reasoning is grounded on the principle of the uniformity of nature as its premise—that is, unobserved events are similar to observed events, so that generalizations obtained from past observed occurrences can be applied to future unobserved occurrences. In Hume's words, 'that instances of which we have had no experience, must resemble those of which we have had experience, and that the course of nature continues always uniformly the same'.[2] But this principle itself is a conclusion reached by induction, and cannot be proved by the understanding or by deductive reasoning. It cannot be proved by deduction because anything that can be proved deductively is necessarily true. But the principle of uniformity is not necessarily true since the deductive framework admits, without logical contradiction, counterexamples for events which have not yet been experienced in which a true antecedent (past patterns of events) is consistent with the denial of a consequent (future patterns of events not similar to the past).

If the principle of uniformity cannot be proved through deduction, and if therefore the validity of induction cannot be established deductively, then it must be proved by causal-probabilistic or inductive reasoning. Yet the validity of such reasoning is precisely what we sought to prove. To justify the principle of uniformity and induction by inductive reasoning is simply question-begging, i.e. a fallacy in which the conclusion is granted for the premises. Therefore, it follows that induction cannot be proved inductively either, because this would count as vicious circularity.

In short, Hume's problem of induction boils down to the idea that experience cannot provide the idea of an effect by understanding or reason (i.e. deductive and causal inferences), but only by the impression of its cause which requires 'a certain association and relation of perceptions'.[3] Understanding cannot produce cause-effect relations or matters-of-fact since such relations are obtained by inductive generalization of observations. Matters of fact rely on causal relations

2. D. Hume, *A Treatise of Human Nature* (London: Green and Co., 1874), 390.
3. Ibid.

and causal relations can only be obtained inductively. But the validity of inductions themselves cannot be corroborated deductively, nor can they be explained inductively. Therefore, what is problematic is not only the derivation of uncertain conclusions from premises by way of induction, but also, and more gravely, the very inductive principle by which such uncertain conclusions are reached.

Argument about law-like regularities from the perspective of the numerical asymmetry of recurring evidences or corroborating observations represents a Humean version of the problem of induction. This is the idea that numerous recurring instances of the same observations in the past are sufficient for establishing law-like regularities that can in turn be used as explanatory components for a phenomenon that is in need of explanation. Such inferences generally take the form of proportional probability arguments constrained by limit functions which specify the parameters satisfying the degree of confirmation:

> Given the hypothesis h expressible in the language L capable of accommodating descriptions of space-time order and elementary number theory,
>
> – the proportion of n-items in the class of properties P is N/M,
>
> – most of the m-membered subclass of P contain a proportion of n-items which approximates that of P such that the next m individual instance $(x_{n+1,} x_{n+2, ...,} x_{n+m})$ are all P and the degree of confirmation of the effective hypothesis $P(x_{n+m+1})$ depending on the parameters of the system of inductive logic approaches 1 as limit, or converges on or remains greater than 0.9, or in the weakest scenario, becomes or remains greater than 0.5 irrespective of the property of the first n individuals (e.g., in the case of $0.5 \leq P(x_{n+m+1})$, if $n=8$, then there must be an m—let us say $m=107$—such that we can state that x_9, x_{10}, ..., $x_{10000000}$ being all green, then it is probable more than one-half that $x_{100000001}$ will also be green), S is an m-membered subclass of P,
>
> – therefore, it is probable that the proportion of n-items in S approximates N/M, once the above approximation is satisfied, the truth of h shall be accepted,

The acceptance of the probability-truth of h can be said to be the inductive counterpart of a deductive conclusion.

However, just because up to the present observations have been manifested in the form of a law-like regularity—in the sense that no instance of observation

within an acceptable limit has violated the pattern—this by itself does not suffice to confirm the truth of the hypothesis, nor does it suffice to establish the truth of its regularity. In other words, it is not just that, given a very long time, more pattern-violating exceptions might be observed, but rather that we cannot prove at any point the definition of the degree of confirmation even in the weakest scenario ($0.5 \leq P(x_{n+m+1})$) in the sense that, save for few instances at the beginning, one cannot establish that it is more likely than not that the next individual m will conform to the proportional probability of observed n individuals. The numerical asymmetry of supporting observations or confirming evidences is precisely that which is to be explained, the *explanandum*. Thus it cannot be posited as that which explains, the *explanans* of its own law-like regularity.

Hume's problem of induction, accordingly, challenges the validity of our predictions—the validity of the connection between what has been observed in the past and what has not yet been observed. We cannot employ deductive reasoning to justify such a connection since there are no valid rules of deductive inference for predictive inferences. Hume's resolution to this predicament was that our observations of patterns of events—one kind of event following another kind of event—creates a habit of regularity in the mind. Our predictions are then reliable to the extent that they draw on reliable causal habits or regularities formed in the mind through the function of memory that allows us to correlate an impression with its reproduction and anticipation. For example, if we have the impression (or remember) that A resulted in B, and if we also witness at a later time and in another situation that 'an A of the same kind resulted in a B of the same kind', then we anticipate a nomological relation between A and B: B is the effect of A, as the cause of which we have an impression.

However, this resolution is also undermined by the problem of the reliability of our memories. Bertrand Russell has formulated the strongest version of the problematic nature of the reliability hypothesis (of memory). According to Russell's 'five minutes ago' paradox,

> There is no logical impossibility in the hypothesis that the world sprang into being five minutes ago, exactly as it then was, with a population that 'remembered' a wholly unreal past. There is no logically necessary connection between events at different times; therefore nothing that is happening now or will happen in

the future can disprove the hypothesis that the world began five minutes ago. Hence the occurrences which are called knowledge of the past are logically independent of the past; they are wholly analysable into present contents, which might, theoretically, be just what they are even if no past had existed.[4]

The gist of the 'five minutes ago' paradox consists of two parts: (1) memory-beliefs are constituted by what is happening now and not by the past time to which the said memory-beliefs appear to refer. In so far as everything that forms memory-beliefs is happening now, there is no *logical* necessity that what is being remembered (the reference of the memory-belief) should have actually occurred or even that the past should have existed at all. (2) There is no logical reason to expect that memory states are in one-to-one correspondence with the rest of the universe. There can be both one-to-many and many-to-many correlations between memory states and external states of affairs. Therefore what we remember as the impression of a cause, a past event, or an observation, may very well be a false memory—either a different memory or a memory of another impression of a cause. Accordingly, our knowledge of the past or of the impressions of causes can also be problematic at the level of logical plausibility and statistical improbability, which does not imply impossibility. Consequently, it is not only the justification of our predictions regarding events which have not been experienced or observed yet that face difficulty, but also our memories—whether understood as physical states or irreducible mental states—of past impressions which have shaped our regularities and habits of mind.

The Humean problem of induction is further sharpened into new riddles or predicaments of induction by Nelson Goodman in his work *Fact, Fiction and Forecast* (1955), and then reformulated in the most radical way by Hilary Putnam in *Representation and Reality* (1988):

Let us imagine that before time *t* (e.g., a hypothetical future time, say 2050) we have observed many emeralds recovered from a local mine (or in Goodman's examples, well-watered grass) to be green, and no emerald to be of another colour. We thus have the following statements based on successful observations,

4. B. Russell, *The Analysis of Mind* (London: George Allen & Unwin Ltd, 1921), 159–60.

Such evidence statements then support generalizations of the kind,

`All emeralds are green` (not just in the local mine but everywhere).

Here the predicate *green* can be said to be a projectable predicate or a predicate that is confirmed by its instances (emerald *a*, emerald *b*, etc.) and can be used in law-like generalization for the purpose of prediction.

Now let us introduce the predicate *grue*. An emerald is grue provided it is green and observed *or* (disjunction) blue and unobserved before the year 2050, i.e. if and only if it is green before time *t* and blue afterwards. Here, the predicate grue does not imply that emeralds have changed their colour, nor does it suggest that, in order for emeralds to be grue, there must be confirmation or successful observation of its instances. We call such a predicate a non-projectable or grue-type predicate.

In the case of grue emeralds, we then have non-projectable generalizations,

`Emerald a is grue, emerald b is grue,` etc.

The generalizations 'All emeralds are green' and 'All emeralds are grue' are both confirmed by observations of *green* emeralds made before 2050. Before 2050, no grue emeralds can be observationally—i.e. inductively—distinguished from any green emeralds. Hence, the same observations support incompatible hypotheses about emeralds to be observed after *t*—that they are green and that they are blue. This is called Goodman's grue paradox. The paradox shows that there can be generalizations of appropriate form which however are not supported by their instances. So now the question is: What exactly is the difference between innocent generalizations like 'All ravens are black' which are supported by their instances, and grue-type generalizations which cannot be so supported by their instances, but nevertheless are equally sound? Or, in other words, how can we differentiate between healthy law-like generalizations based on projectable predicates and grue-like (or not law-like) generalizations based on non-projectable predicates? This is Goodman's new riddle of induction, which

asks why it is that we assume that, after time *t*, we will find green emeralds but not grue emeralds, given that both green and grue-type inductions are true and false under the same set of conditions such that,

– Based on the observations of many emeralds, a miner using our common language will inductively reason that all emeralds are green. The miner forms the belief that all emeralds to be found in the mine or elsewhere are and will be green before and after time *t*.

– Based on the same set of observations of green emeralds, a miner using the predicate 'grue' will inductively reason that all emeralds observed after time *t* will be blue, even though thus far only green emeralds have been observed.

Goodman's response to the paradox is as follows: the predicate green is not essentially simpler than the predicate grue since, if we had been brought up to use the predicate grue instead, it could very well be the case that grue would no longer count as nonsensical or as more complex than the predicate green by virtue of being green and blue. In that case, we could use predicates grue and bleen (i.e. blue before time *t*, or green afterwards) just as we now use the predicates green and blue. An objection can be made that, unlike green, grue is artificially defined disjunctively, and that therefore the natural predicate green should be preferred. Per Goodman's response, there is no need to think of grue and bleen-type predicates as disjunctive predicates. They can easily be thought as primitive predicates such that the so-called natural or simple predicate green can be defined as *grue if observed before time* t *or bleen thereafter*. Hence even the predicate green can be shown to be disjunctive. To this extent, the hypotheses we favour do not enjoy a special status because they are confirmed by their instances but because they are rooted in predicates that are entrenched in our languages as in the case of green. If grue and bleen were entrenched, we would have favoured hypotheses of their kinds.

If projectable and non-projectable predicates are equally valid, then what kinds of constraints can we impose on a system of inductive reasoning that will exclude grue-type non-law-like generalizations? Goodman's response is that no purely formal-syntactical constraints can be sufficient to distinguish projectable from non-projectable predicates. The only way to tell apart healthy green-like

from grue-like properties is in terms of the history of past inductive inferences. The reason we use green and not grue is because we have used green in our past inductions. But equally, we could have been using the predicate grue rather than green so that we could have now justified reasons to use grue and not green.

In his radical version of the new problem of induction, utilizing Gödel's incompleteness theorem, Putnam adopted and refined this argument to show that inductive reasoning cannot be formalized—i.e., that there are no syntactical or formal features of a formalized inductive logic that can be used to make the aforementioned distinction.

Now since the epistemic traction of the human mind on reality ultimately comes down to the validity of induction, the unformalizability of induction implies that the mind—whether that of a detective or a scientist—can never even provide a formal and hence modern scientific (namely, mathematized) account of itself. In other words, according to Putnam, 'if human minds have every conceivable computational description, it makes no sense to take the realist line that human beings have a computational description, even though we can't discover it'.[5] The claim that the human mind has a particular computational description or formal model lacks explanatory power since such a computational description would fall under Gödel's incompleteness theorem in the sense that there is no way to correctly distinguish between the computational description of the mind and any other computational description. Therefore, any inductive prediction made by such a computational description can be verified save for one: that it is the correct description of the mind. Whereas Hume and Goodman employ the problem of induction to challenge the predictive-inductive descriptions of the external world and events, Putnam reinscribes the problem of induction at the level of the inductive mind itself: Just as induction does not say anything about its nature, the computational mind does not reveal anything about its nature either.

Since every method of epistemic inquiry has to have an inductive component, this poses a serious problem for the ultimate legitimacy of our epistemic inquiry. Putnam's resolution, in the vein of Hume, is that even though induction cannot be formalized, and can reveal nothing about its nature, we ought to trust our intuitive and ordinary inductions, for they are the result of evolution (the evolution of memory, language, etc.). What distinguishes our ordinary inductions from grue-type induction is their elegance or simplicity. But resorting to the principle

5. J. Buechner, *Gödel, Putnam, and Functionalism* (Cambridge, MA: MIT Press, 2008), 27.

of simplicity or Occam's razor is not sufficient to license our ordinary inductions either, since the principle of simplicity is only a contextual and pragmatic matter of favouring one induction over another. Put differently, there is nothing inherently simple about the world or mind. If simplicity was sufficient to distinguish projectable from non-projectable predicates, ordinary inductions from complex grue-type inductions, false theories from true theories, then, as Adolf Grünbaum has detailed, there would be no reason to endorse the Darwinian theory of life over the far simpler theistic theory of creationism.[6] It is in this sense that the radicalization of the problem of induction can be understood as the razoring of Occam's razor.

Moreover, the Putnamian appeal to evolution as a justification of our ordinary inductions—just like Hume's resolution—simply defers the problem of induction to a lower level, sweeping it under the carpet of evolution. To trust evolution in order to trust our inductive capacities so as to trust the legitimacy of our epistemic inquiries is only an act of faith in the blind god of evolution, whose gift of inductive reliability should not be mistaken for *our* epistemic birthright. The cognitive lesson to be learned here is that only by distilling the superacid of epistemological scepticism can we rescue the legitimacy of our knowledge and the coherency of critical realism. Epistemology without scepticism about the conditions of epistemic possibility is predisposed to dogmatism, and scepticism without the rational ambitions of epistemic inquiry is doubt as debilitation. In the end, the true detective is not someone who investigates the state of affairs by being sure of the reliability of the methods of investigation, but one who brings the reliability of the method of detection under the scrutiny of *skeptikos* or thoroughgoing investigation. As Plato reminds us in *Meno*, the fact that there is doubt is because there is a coherentist web of knowledge as its condition of possibility. And where there is knowledge as a continuous web of truth-candidates—rather than a collection of discrete facts or canonical given truths—methodological scepticism is an essential component of knowledge that ought to be embraced. A realism that neither instigates the cognitive provocations of epistemological scepticism nor is up to the task of taking on its challenges is not worth its name.

6. A. Grünbaum, 'The Poverty of Theistic Cosmology', *British Journal of Philosophy of Science* 55:4 (2004), 561–614.

Joshua Johnson

Mutually Accelerating Demands

The splitting of the atom that inaugurated the end of World War II and the beginning of the Cold War made manifest both the power and increasing complexity of science. As the development of technology has intensified humanity's capacity for destruction, it has also accelerated the pace of decision-making beyond effective human understanding and control. The atomic age exposed not only the fabric of physics, but also the complex weave of human interaction at scales that could not easily be conceptualized by any existing system. Today, the urgency of the cultural and political tension that kept the world in its grip during the Cold War has dissipated, but the fundamental rift between what *is* and what *ought* to be has become increasingly irresolvable.

This problematic runs through the *Cold War/Cold World* project: Robin Mackay's essay begins with the catastrophe of all existing imaginaries prompted by the Cold War, and concludes on the increasing impotence of representation, where the proliferating production of images conceals an opaque process of cyber-subjugation. Amanda Beech leverages this condition of alienation as a challenge to existing artistic strategies. She argues that the critical insight regarding the limits of human finitude has devolved into a naive libidinal dogmatism that must be replaced with a more reasoned constructive image of the subject. Reza Negarestani examines the dialectic between inductive scepticism and rational certainty, warning against the extremes of either. Brian Evenson suggests that an intuitive and affective excess may colour our memory, creatively disrupting and mediating the past. Christine Wertheim argues that a psychological lack drives our need for both certainty and maturation.

To engage with this broader conversation, I would like to begin by suggesting a generalized interpretation of the metaphors employed under the *Cold War/ Cold World* banner: on the 'Cold War' side of the solidus we find the questions of action, intentionality, and decision-making, or the problem of what *ought* to be. On the other side, the 'Cold World', we find facts, history, systematicity, and

ontology, or the question of what *is*. In many of the various essays presented, the question of what it *is* that requires descriptive and explanatory competence vacillates between the complexity of the world external to minds and the complexity of the minds that perceive the world. In this paper I will focus on the latter problem, aiming to show how an explanation of minds provides ampliative resources for determining how we *ought* to engage the complexity of the world.

As It Ought To Be

Reza Negarestani introduces the problem of induction in his essay as a foil to the limits of dogmatic scientism: Induction, as he notes, is the idea that the regularity of an appearance does not guarantee the relation between cause and effect, but merely provides evidence toward the inference that a cause implied an effect. The relation between *is* and *ought* is tangled with this problem of induction, beginning with Hume's articulation that no necessity holds between what *is* and what *ought* to be, since it is not clear how a new relation can be generated in excess of what is given in the original proposition.[1] This suggested an ethical and epistemic scepticism, as Hume regarded all justified knowledge as deriving from either logic or experience, and statements with regard to future states of affairs proceeded from neither.

The twentieth-century philosopher Wilfrid Sellars engaged the is/ought problem along broadly Kantian lines. Kant parried Hume's scepticism with a deontic view that *ought* implies *can*[2]—that is, if I ought to do something, in order for me to be responsible for it, I must have some capacity to do it. As such, what we *ought* to do is subject to defeasors, which may condition how we ought to act in respect of countervailing information. Turning on this point, *ought* presupposes an *is;* if I think I ought to be able to fly by flapping my arms, I have based my commitment to this course of action on mistaken beliefs regarding the nature of human physiognomy and the constraints of local physics.

In Sellars's time the question of the is/ought relation had split between those who were *natural ethicists* and held that there is a causally reducible story to be told regarding ethical actions, and those who were *ethical intuitionists,* who

1. D. Hume, *A Treatise of Human Nature* (Oxford: Clarendon Press, 1896), <http://oll.libertyfund. org/titles/342>.
2. I. Kant, *Critique of Pure Reason* (Cambridge: Cambridge University Press, 1998), 540 (A548/B576).

argued that ethical matters were logically irreducible to naturalistic descrip-
tions. Sellars staked out a position between both camps, agreeing with logical
irreducibility and causal reducibility, while denying that causal reducibility goes
hand in hand with logical reducibility.[3] He argued that a naturalist account
may be provided for *oughts* through a detailed explanation of the patterns of
psychological and social behaviour and complex microphysical events, but that
the concepts and norms upon which we base our intentional actions are not the
same kind of thing as the causal processes which give rise to them, and imply
something more than those mere processes.

> From this point of view, the irreducibility of the personal is the irreducibility of
> the 'ought' to the 'is'. But even more basic than this (though ultimately, as we
> shall see, the two points coincide), is the fact that to think of a featherless
> biped as a person is to construe its behaviour in terms of actual or potential
> membership in an embracing group each member of which thinks of itself as a
> member of the group.[4]

Oughts are not explanatory or classificatory, but are characteristic of the norms
and intentions of a community towards itself. However, these communal prac-
tices, and the individuated modes of relating to them, presuppose and produce
particular causal and naturalistic structures that may be defined in scientific
terms. As philosopher James O'Shea puts it: 'For Sellars, it is the specific
nature of the resulting non-normative causal relations and real mind-world
isomorphisms that enable our cognitive systems—at least, at the bottom level
and when we've got things right—to be mirrors of nature that correspond
to empirical reality.'[5] Ideally, Sellars suggests, understanding what it is to be
engaged in normative practices will better equip us to recognize the whole
community of persons in its most universal sense.

How do we understand the individuals that make up this universal prospectus
and the demands placed upon them? The crisis introduced by the atomic bomb

3. J. O'Shea, 'On the Structure of Sellars' Naturalism with a Normative Turn', in W. deVries (ed.),
Empiricism, Perceptual Knowledge, Normativity and Realism (Oxford: Oxford University Press, 2009).
4. W. Sellars, 'Philosophy and the Scientific Image of Man' (1962), in *Empiricism and the
Philosophy of Mind* (Cambridge, MA: Harvard University Press, 1997), 1–40.
5. Ibid., 13.

made an imperative of understanding not only the scope of normative behaviour on a global communal level, but also the cognitive capacities of individuals engaged with this expanded complexity. Novel models were required to develop top-down and bottom-up pictures of human behaviour.

Atomic Fusion

Managing the power of technology introduced new risks, turning the global stage into a shadowboxing game predicated on the irrationality of agents whose decision-making processes were opaque, and new methods had to be devised to contain the increasing uncertainty:

> What was distinctive about Cold War rationality was the expansion of the domain of rationality at the expense of that of reason, asserting its claims in the loftiest realms of political decision making and scientific method—and sometimes not only in competition with but in downright opposition to reason, reasonableness, and common sense.[6]

Amongst those attempting to form viable decision-making procedures in response to the Cold War was Herbert Simon, a polymath whose work stretched across the fields of psychology, sociology, economics, and computer science. Attempts to formalize any standard procedures for responding to the dynamic and ramifying pathways of a complex situation presented a difficult calculation problem: as the number of factors accounted for in any model increased, the computational process became concomitantly expensive. Models that systematize the interaction between multiple agents must take into account the constraints on the rationality of those agents themselves. Agents entangled in dynamic systems must often reason from finite information and with limited resources. What an agent ought to do in a given situation was multiply conditioned and constrained by not just by their environment but by limits on their internal cognitive capacities.

To resolve this intractability Simon borrowed ideas from psychology and management theory. He proposed a model of bounded-rationality that employed,

6. P. Erikson et al., *How Reason Almost Lost Its Mind: The Strange Career of Cold War Rationality* (Chicago: Chicago University Press, 2013), 2.

not necessarily the optimal answer to a given problem, but one that was *satisficing* or 'good-enough' to achieve a specified goal. These solutions broke down a complex problem into more manageable steps and recast them within a more familiar problem-space with a defined limit. Simon's heuristic techniques attempted to capture the computational limitations on absolute rationality and to make a virtue of their constraints when modelling systems.[7]

However, heuristics are context-sensitive and, once removed from their adaptive niche, switch from being advantageous short cuts to being systematically biased in favour of their reductive scope if not carefully implemented. Furthermore, while Simon's approach was descriptive and even prescriptive in limited cases, it could not be easily generalized and it lacked the robust explanatory power necessary to describe the individuated epistemic economies of the agents that it might model.[8] Nonetheless, Simon's work helped to lay the foundations for modern decision theory and influenced contemporary cognitive science. The recognition of computational constraints on individual rationality suggested that science must look for explanations that could develop robust behaviour from simpler and empirically tractable mechanisms.

Code War/Convergent World

As a naturalist and a normativist, Sellars introduced the terms 'manifest image' and 'scientific image' as ways of characterizing the distinction between our given understanding, and the developed theoretical frameworks under which our commonsensical approach to the world is reinterpreted in the increasingly robust and generalized vocabulary of scientific description. However, this also suggested a tension between the two modes of understanding:

> Thus although methodologically a development within the manifest image, the scientific image presents itself as a rival image. From its point of view the manifest image on which it rests is an 'inadequate' but pragmatically useful likeness of a reality which first finds its adequate (in principle) likeness in the scientific

7. H.A. Simon et al., 'Decision Making and Problem Solving', *Interfaces* 17:5 (1987), 11–31.
8. K.V. Katsikopoulos, C.-H. Lan, 'Herbert Simon's spell on judgment and decision making', *Judgment and Decision Making* 6:8 (December 2011), 722–32

image. I say, 'in principle', because the scientific image is still in the process of coming into being [...].[9]

The intense pressures of the Cold War accelerated the development of the scientific image, but the climate of urgency did not resolve the demands it provoked. The counter-intuitive strategies suggested under the Cold War aegis must be tempered into robust models and brought into conversation with our more commonsensical understanding of the world.

Recent accounts of cognition work in conjunction with contemporary neurobiology and artificial intelligence research to suggest a predictive processing model that may help to explain how the brain is capable of developing robust cognitive resources from simpler error-correcting processes that absorb the informational costs of modulating environmental complexity:

> In mammalian brains, such errors look to be corrected within a cascade of cortical processing events in which higher-level systems attempt to predict the inputs to lower-level ones on the basis of their own emerging models of the causal structure of the world (i.e., the signal source). Errors in predicting lower level inputs cause the higher-level models to adapt so as to reduce the discrepancy. Such a process, operating over multiple linked higher-level models, yields a brain that encodes a rich body of information about the source of the signals that regularly perturb it.[10]

Modern image, audio, and video compression techniques, for example, operate along similar principles. Compression can transmit a significant amount of lossless information by encoding only the most 'unexpected' information in the image. A common glitch one encounters when viewing improperly compressed digital video files is the pixelation that occurs around a figure moving in an otherwise still shot. Once compressed, the information for all the pixel values in each frame of the video need not be stored, but only the information regarding which pixels have varied as the scene progresses. Studies have shown that ganglion

9. Sellars, 'Philosophy and the Scientific Image of Man', 20.
10. Andy. Clark, 'Whatever next? Predictive brains, situated agents, and the future of cognitive science', *Behavioral and Brain Science* 36:3 (June 2013), 181–204: 181.

cells in the human retina operate according to similar principles—transmitting to the brain only the variance in expected information.[11]

This also helps explain how humans develop heuristics that produce cognitive biases when applied outside their evolutionarily developed expectations. As Simon noted, information processing is expensive and minds, like computers, are constrained by their available resources. Animals with more veridical perceptual systems face an evolutionary disadvantage because the systems that are required to optimally model the environment incur a greater resource cost. Animals with less accurate, but more efficient models of representation tend to outcompete their calorie-hungry cousins.[12] Long-term invariants are built into evolutionarily adapted systems, which simply hardwire hypothesis about the environment to cut costs. Rapid change to the external environment exposes the inductive assumptions that form the basis of our evolutionary inheritance. To reiterate the point that Negarestani makes in his essay, '[t]o trust evolution, in order to trust our inductive capacities, so as to trust the legitimacy of our epistemic inquiries is only an act of faith in the blind god of evolution, whose gift of inductive reliability should not be mistaken for our epistemic birthright.' Despite the limits of evolutionarily given capacities, models which can provide explanatory depth for these constraints also help to propose the means for surpassing them.

I do not have the space here to fully elaborate the many examples that suggest the predictive processing model gets many things correct about at least the lower-level perceptual capacities exhibited by human beings, nor do I wish to suggest that the theoretical framework provides a comprehensive explanation for all human capacities. What I do want to suggest, however, is that the explanation, demonstration, and replication of particular sub-processes of human function such as vision, categorization, and learning provide comparisons with human ability, allowing us to decompose and re-engineer the conditions under which we understand the world and one another.

11. T. Hosoya, S.A. Baccus, and M. Meister, 'Dynamic predictive coding by the retina', *Nature* 436:7 (2005), 71–7.
12. D. Hoffman, 'The Interface Theory of Perception: Natural Selection Drives True Perception To Swift Extinction', in S. Dickinson, M. Tarr, A. Leonardis, B. Schiele (eds.), *Object categorization: Computer and Human Vision Perspectives* (Cambridge: Cambridge University Press, 2009), 161–3.

Aside from the acknowledgement that the nuclear threat has not disappeared from humanity's horizon, the rapid development of industrial capitalism has compounded the existential danger in the form of climate change and the immiseration of a growing surplus population. Meanwhile, the explosion of the internet and other communication technologies has multiplied and fragmented humanity's social and political fabric. Sellars believed that the scientific and manifest images should become 'stereoscopically' fused, encapsulating traditional human-oriented modes of understanding and operation such as intentionality, rules, and norms, and upgrading their commitments to better orient practical action within the world:

> Thus, to complete the scientific image we need to enrich it not with more ways of saying what is the case, but with the language of community and individual intentions, so that by construing the actions we intend to do and the circumstances in which we intend to do them in scientific terms, we directly relate the world as conceived by scientific theory to our purposes, and make it our world and no longer an alien appendage to the world in which we do our living.[13]

More exacting understanding of human-level heuristic strategies allows us to respond to cognitive biases and to work with given constraints, rather than attempting to impose top-down corrections. Explaining and describing the perceptual tools that characterize how human beings represent or fail to represent their environment suggests aesthetic strategies that can be rationally and constructively developed, as Beech has argued. Furthermore, an elaboration of these processes, untethered from a biologically determined threshold, may allow us to extend our given capacities and to confront problems of scale for which we are not evolutionarily equipped. What it *is* to be human must be elaborated so that we may decide how we *ought* to extend our capacities.

13. Sellars, 'Philosophy and the Scientific Image of Man', 39.

Patricia Reed

The Cold World and the Collective Subject

> To find the causal link between our world and the otherworld is the matter of understanding and imagining what ought to be done in our world from the perspective of the postulated possible world, this is the very first defining step of resistance today.[1]

Our 'Cold World' of planetary-scale complexity underwritten by logistics, computation, big data, and hypercapitalism not only signals the 'apparent impossibility' of grasping 'what this world is',[2] it also ushers in an additional keyframe in the history of humanity's Copernican humiliations. Although the Cold World is of human making (at least, that of some humans), the agglomerative results of this 'accidental megastructure'[3] we now find ourselves *in* and complicit *with* forces us to contend with a mutated self-image, as decentred bit-users *in* and *for* its manifold operations—multiscalar operations both unfathomably large and infinitesimally small. The tendency to envision this 'decentring' as either debilitating (engendering states of resignation), or as one that renders the question of human subjectivity irrelevant (inviting the blind celebration of machinic 'efficiency') offers us only reductive framings of this re-positioning. What this 'humiliation' demands, rather, is the re-plotting of our ex-centric non-radiance as a cartographic enterprise, forging a recalibration of our perspectives and therefore our capacities (what we *can* do), in substantively *hypothetical* ways. To *grasp* and be *grasped* by this humiliation is to incorporate a perspectival shift, enabling new models of cognitive and material activity afforded by this novel conceptual diagram. Today, the affective 'heat' emanating from the experience of estrangement in the Cold World can be read as a rejection (in

1. R. Negarestani, 'Antinomies of Experience and the Question of the Transcendental Struggle', *Résistance(s)*, lecture at LUMA Foundation, New York, February 2017.
2. A. Beech, 'Cold World and Neocon Noir', in this volume.
3. B. H. Bratton, *The Stack: On Software and Sovereignty* (Cambridge, MA: MIT Press, 2015), xviii.

some cases, a reactionary refusal) of this human decentring; this rejection manifests itself throughout the political spectrum (with vastly different results), from the 'making great again' of parochial isolationism, coupled with its inherent racisms/sexisms, to the insistence on guarding against any infringement of the 'authenticity of lived experience' as producer of (particular and not universal) truths.[4] While there are undeniable threats to our well-being, and to multi-species life itself, endemic to the *existing* operations of the Cold World (including our shared environmental needs), what these rejections symptomatically index is a conceptual deficiency in imaginatively resituating ourselves from the vista of the otherworld. Such a deficiency ramifies *what is* into a negation of the hypothetical, whether motivated explicitly by self-interest or compelled implicitly by habit. Any progressive socio-political project imbued with the spirit of 'optimist realism'[5]—that is, an optimism commensurate with the material and cognitive predicament of Cold World actuality—necessitates a rearticulation of (mythic) givenness, that foundational diagram tacitly mapping where we stand (our generic situatedness), and from which a cascading of new possibilities for coexistence can unfold, dismantling *what is* in its wake.

If art is to participate in such a project, it is as a vehicle for the generation of experiences postulated from the otherworld; a means for the 'abduction of ourselves by perspectives that relativize' sensory apprehension.[6] What this entails is a synthetic plea for art, for an art where direct human experience is neither exclusively privileged nor dismissed outright, but is charted as a continuum between the personal and the impersonal, the phenomenal and the (non-intuitively) conceptual. In light of the figure of the non-radiant human, which deals a blow to claims on agency strictly tethered to selfhood and immediacy driven by particular experiences alone, the relativization of singular experience qua the abstractly conceptual must insist on the mutual influence between the two: conceptual innovations offer new schematics through which the world is encoded and rendered (partially) graspable to us, transforming the ways in

4. Negarestani, 'Antinomies of Experience and the Question of the Transcendental Struggle'.
5. P. Reed, 'Optimist Realism: Finance and the Politicization of Anticipation', in G. Lovink, P. de Vries and I. Gloerich (eds), *Moneylab Reader #2* (Amsterdam: Institute of Networked Cultures, forthcoming 2017).
6. R. Mackay, 'Perspective, Alienation, Escape: An Introduction', Urbanomic Documents, 2013, <https://www.urbanomic.com/document/perspective-alienation-escape-an-introduction/>.

which we can navigate reality both *pragmatically* and *semantically*.[7] That is to say, the concretely situated experience assumes abstract conceptuality as a condition of its enablement, while this structure of enablement is conditioned by the phenomenal interface through which abstractions are instrumentalized. There is always a dynamic correlation between the territory (experience) and the map (conceptual schematics organizing the world).[8]

Extrapolating this insistence upon the social urgencies facing us in the Cold World, and the impotence of individualism to substantively and enduringly confront them, a new model for non-radiant human subjectivity demands *construction*. This means speculating on a collective subjectivity[9] premised on shared, perspectival (conceptual) coherence (and not the homogenization of *differential* experience); not only within a horizon of maximizing human solidarities in light of our common ex-centricity, but also one of aggregating non-human computational forces within its cognitive, and therefore actionable, repository. With the complexity of the Cold World greatly superseding our stand-alone cognitive capacities (let alone the human disciplinary divisions schematized in dominant epistemological frameworks), computational modelling is an indispensable tool for achieving more robust traction on a world that increasingly slips from the purview of strictly human intuition. If the *depersonalisation* of the Cold World is to escape an equation with *dehumanisation* (a trajectory that is arguably quite probable in our current landscape of neoliberal affordances, despite the terms being discrete), it becomes increasingly pressing to construct this collective subject able to mobilise on the level of the generically impersonal. Can the debilitating variant of alienation we experience in the Cold World be generatively *détourned* into an impetus for a non-radiant collective self-understanding that requires alienation from selfhood as such? The possible sensation of this otherworldly landscape beyond selfhood necessitates departure from the vantage point of the hypothetical non-radiant human, and a navigational probing from that perspective, not the mimicry of *what is* (individualism) as a 'somatic reflex

7. G. Longo, 'Space and Time in the Foundations of Mathematics, or some challenges in the interactions with other sciences', American Mathematical Society/SMF Conference, Lyon, July 2001, <http://www.di.ens.fr/users/longo/files/PhilosophyAndCognition/space-time.pdf>.
8. Glass Bead, 'Castalia, the Game of Ends and Means', editorial in *Glass Bead Journal*, Site 0, February 2016, <http://www.glass-bead.org/article/castalia-the-game-of-ends-and-means/?lang=enview>.
9. M. Fisher, *Capitalist Realism: Is There No Alternative?* (London: Zero Books, 2009), 66.

to contemporary culture's overpowering protocols'.[10] The abductive power of the hypothetical lies in its ability to fashion narratives for that which exceeds (or evades) observation and/or known existing reality. For art, to depart from the perspective of the hypothetical is equal to the construction of conditions for experiencing the non-given or inexistent otherworld, a type of reasoned fiction that generates new cartographies for action in reality because of the novel vistas it makes compatible with sensation. For we non-radiant bit-users, to intervene in the dismal trajectory of reality today we need to *use*, and not be *used by*, the alienating forces of the Cold World; to confront it not in the register of an incapacitating individual alienation leading to states of utter disconnection, but that of a collective alienation that can separate us from *what is*, and move us towards new modes of grasping and being grasped by the hypothetical otherworld.

10. K. Stakemeier, 'Exchangeables: Aesthetics against Art', *Texte zur Kunst* 98 (June 2015), 124–43.

Notes on Contributors

ÉRIC ALLIEZ is a philosopher and Professor at Université Paris 8 and at the Centre for Research in Modern European Philosophy at Kingston University, London. He is author of *Capital Times* (preface by Gilles Deleuze, University of Minnesota Press, 1996), *The Signature of the World: Or, What is Deleuze and Guattari's Philosophy?* (Continuum, 2004), *The Brain-Eye: New Histories of Modern Painting* (Rowman and Littlefield, 2016), *Undoing the Image* (Urbanomic, 2017–18), and *Wars and Capital*, with Maurizio Lazzarato (Semiotext(e), 2017).

AMANDA BEECH is an artist and writer living in Los Angeles. Drawing from popular culture, critical philosophy, and real events, her work manifests in different media including critical writing, video installation, drawing, print, and sculpture. Using a range of rhetorical and often dogmatic narratives and texts, Beech's work poses questions and proposes models for a new realist art in today's culture: that is, a work that can articulate a comprehension of reality without the terminal mirror of a human identity. Beech is Dean of Critical Studies at California Institute of the Arts.

BRIAN EVENSON is the author of a dozen books of fiction, most recently the story collection *A Collapse of Horses* (Coffee House Press 2016) and the novella *The Warren* (Tor.com 2016). He is the recipient of three O. Henry Prizes, a Guggenheim Fellowship, an NEA Fellowship, and the ALA-RUSA Award. His work has been translated into French, Italian, Greek, Spanish, Japanese, Persian, Slovenian, and Turkish. He lives in Los Angeles and teaches in the Critical Studies Program at California Institute of the Arts.

JOSHUA JOHNSON is a New York based artist and writer. He works across a diverse range of media including sculpture, video, online media, installation, and research-based practices. His art has been shown at Outlet Gallery, Parallel Arts Space, Louis B. James (all NY), amongst others. In 2015, he founded the ongoing research and resource hub Uberty (http://uberty.org). In 2013, he organized and edited *Dark Trajectories: Politics of the Outside* ([NAME] Publications),

a compilation of recent philosophy. He is engaged in several collaborative projects, including Office for Applied Complexity, and was a 2016 Artist's Alliance resident artist.

MAURIZIO LAZZARATO is a sociologist and philosopher living and working in Paris. He is the author of *Governing by Debt*, *Signs and Machines: Capitalism and the Production of Subjectivity*, and *Wars and Capital*, with Éric Alliez (all published by Semiotext(e)).

ROBIN MACKAY is director of Urbanomic, has written widely on philosophy and contemporary art, and has instigated collaborative projects with numerous artists. He has also translated a number of important works of French philosophy, including Alain Badiou's *Number and Numbers*, Quentin Meillassoux's *The Number and the Siren*, François Laruelle's *The Concept of Non-Photography* and Éric Alliez's *The Brain-Eye* and *Undoing the Image*. Mackay is currently a Research Fellow at Goldsmiths University of London.

REZA NEGARESTANI is a philosopher. He has contributed extensively to journals and anthologies and lectured at international universities and institutes. He is the author of *Intelligence and Spirit* (Urbanomic/Sequence Press, forthcoming 2017).

PATRICIA REED is an artist, writer, and designer based in Berlin. Her work concerns the entanglements between epistemology, diagrammatics and modelling with politics, adapted to planetary scales of cohabitation. Recent texts include: 'Xenophily and Computational Denaturalization' in *e-flux Architecture Artificial Labour* series; and 'Optimist Realism: Finance and the Politicization of Anticipation', in *Moneylab Reader #2* She is a member of the Laboria Cuboniks and Office for Applied Complexity working groups.

CHRISTINE WERTHEIM is author of eight books including three poetic suites, *The Book of Me*, *mUtter-bAbel*, and *+|'me'S-pace*, experiments in auto-bio-graphy fusing graphics and text to explore the potentialities of the English tongue, and the relationship between suppressed infantile rage and global violence. With her sister Margaret, she is co-creator of the project Crochet Coral Reef

(crochetcoralreef.org), and co-director of the Institute For Figuring, a non-profit focusing on the aesthetic dimensions of science and mathematics. She teaches at the California Institute of the Arts.

JAMES WILTGEN teaches Critical Studies at the California Institute of the Arts Currently, his research interests include cultural production in Mexico City, the politics of Porto Alegre, and theoretical approaches to the developing world, with particular emphasis on subjectivities, technology, and biopower. He is a founding member and co-editor of the innovative journals *Strategies: A Journal of Theory, Culture and Politics*, and *Emergences: Journal for the Study of Composite Cultures*. In addition, he has also done the primary research for a number of documentary film projects, including ones on global cities and Los Angeles.